REINVENT YOURSELF

*Personal, Positive Growth through
any Mess, Movement and Mission!*

RICK DENLEY

REINVENT YOURSELF

Quantity sales special discounts are available on quantity purchases by corporations, associations, and others. For details, contact the publisher at the address above.

Orders by U.S. trade bookstores and wholesalers. Email info@ BeyondPublishing.net

The Beyond Publishing Speakers Bureau can bring authors to your live event. For more information or to book an event contact the Beyond Publishing Speakers Bureau speak@BeyondPublishing.net

The Author can be reached directly at RickDenley.com

Manufactured and printed in the United States of America distributed globally by BeyondPublishing.net

BEYOND
PUBLISHING

New York | Los Angeles | London | Sydney

ISBN: 978-1-949873-44-3

TABLE OF CONTENTS

Preface ... 7

Acknowledgements .. 10

Introduction ... 13

Chapter One: *Harnessing the Energy in Change* 17
 Our Brains and Change – Understanding How We Tick 17
 Habits Are Stronger Than Willpower ... 18
 We View Reinvention Under a Suspicious Eye 19
 Risk Versus Reward – A Cranium Debate 19
 Success Formula ... 20

Chapter Two: *Why? Digging Deep for Your Reason* 21
 Clarifying Your Reasons ... 21
 Related Story – A Change From My Life's Passion 23
 Exercise – Your Why ... 28
 Exercise: A Letter to a Friend .. 29
 Related Story – Charity Startup ... 29

Chapter Three: *What? Visualizing Your End Goal* 31
 Related Story – Rick's Vision of His Fight 32
 Exercise – Mental Visualization .. 32

Chapter Four: *HOW? Actions to Reach Your What* 37
 Adaptability .. 38
 Related Story – Rick's Story of Business 40
 Commitment / Dedication ... 42
 Related Story – Breaking the Chain .. 43
 Communication .. 44
 Related Story – Moral Suasion .. 47
 Passion ... 49
 Related Story – Rick Entering KBC ... 50
 Lifelong Learning and Improvement .. 52
 What is Emotional Intelligence/Quotient? 53
 Why is EI important for us when reinventing ourselves? 53
 Related Story – My EI Learnings ... 54
 Fearless ... 55
 Focus .. 56
 Related Story – Eye of the Tiger .. 58
 Faith ... 59
 Embrace Uncertainty ... 61
 Related Story – From Corporate to Entreprenuer 62
 Humility and Ego ... 63
 Related Story: Get Humbled ... 64
 Exercise: Identify Your Strengths and Weaknesses 65

Chapter Five: *WHEN? Choosing Your Correct Timing* 67
 Related Story – Second Career Comeback ... 68

Chapter Six: *Barriers! Overcoming the Challenges Ahead* 71
 Fear ... 72
 Related Story: Facing My Fears .. 73
 Exercise: Addressing Your Fears .. 77
 Criticism ... 79
 Rejection ... 80
 Assholes .. 81
 Pressure .. 82
 Financial ... 84
 Physical and Emotional Barriers ... 84
 Distractions .. 85
 Exercise – Multitasking ... 86
 Related Story – Prioritization by Warren Buffett 86
 Exercise: Predicting and Addressing Potential Barriers 87
 Getting Tired ... 87
 Related Story – Rick's Break ... 88

Chapter Seven: *Tools - Using the Correct Wrench* ... 89
 Related Story: Bloodied Knuckles ... 91
 Support ... 92
 Reach Your Goal Faster ... 92
 Exercise: Identifying Available Resources ... 92
 Mentors and Coaches .. 93
 Exercise: Identify Your Inner Circle ... 94
 Creating a Mentor Pick Checklist .. 94
 Exercise: Determining Potential Mentors/Coaches 96
 Exercise: Create a 90-Day Plan .. 98

Chapter Eight: *GRIT - Staying the Course* ... 101
 Related Story: Lost in the Mountains .. 102
 Staying the Course .. 104
 Exercise: A Letter to Yourself ... 104
 Check-In's ... 105
 Related Story: Mid Journey Check-In ... 105
 Exercise: Checking In .. 106
 Stickiness – Staying Power .. 106
 Exercise: Previous Positive Experience .. 107
 Rules – Breaking the Rules .. 108
 Related Story – Rules of the Ring .. 108
 Exercise: Setting Your Own Rules ... 110

Chapter Nine: *Reflection - Using the Past Productively* 111

Chapter Ten: *Call to Action!* .. 113

PREFACE

It was a typical sunny Sunday morning on my lone cycling ride. One I'd done a hundred times previously. The brilliant sunshine was sharing its warmth on my back as I headed north towards Orangeville, up Kennedy Road. The shadow of myself was cast out long in front of me, as the sun began to rise. The smells of fall were in the air, and some tress had dropped their leaves particularly early this year, indicating a potentially long and cold winter. The leaves blew across me, in front of my spinning front wheel, as I headed towards the rolling hills.

The hills were a challenge. Not a momentous one, but enough to raise my heart rate and force my lungs to their capacity. I had now passed through the flats of the farming fields. It was only weeks earlier the farmers had harvested their crops for the season, leaving tall dying corn stalks to blow in the fall winds. I made it up and over each hill slowly, then felt the exhilaration of the downhill within the brisk breeze, which suddenly turned into a hurricane whistling by my ears!

At a small section of a slow upgrade was where I had reached my turning point. The road ended and I prepared to head back. Today, I stopped for a brief moment—I'm not sure why. Typically, I did a simple turn and immediately headed back home. But today was different. I quenched my thirst with a long and satisfying drink from my water bottle and looked out towards the beautiful landscape I was about to fly by.

I had a sudden realization—I was in danger of not fulfilling my second half of my life's dreams. As I stared in the direction leading to the north, my future looked stiflingly planned, boring string of routine days, with one day running into the next. *What do I want to do with the second half of my life, anyway?* I asked myself. Answering myself in my head, I concluded ; *I want to be happy, extremely happy, and healthy. I want*

to make a positive impact for others, make a dollar and a difference, and leave a legacy, beyond my amazing sons.

But I had never thought about what that future me would look like, and what exactly I'd be doing at this point. How would I change for the better? How could I reinvent myself to meet my goals and dreams for the second half of my life? I wanted to be sure I lived my life with no regrets. The endless possibilities of what could be swirled in my head and rolled out before me into the horizon.

I first became interested in the idea of reinventing myself when I realized small tweaks weren't going to get me where I wanted to be. This was going to take monumental change! What is it, that is so powerful, that we are willing to make these monumental changes in our lives? And what constitutes a reinvention of oneself?

Reinventing ourselves is not easy. It does not happen over night and certainly does not happen without considerable planning, support, communication, determination, sacrifice and passion.

> *"I think reinvention is not so much about changing the appearance of things, it's about connecting with a deeper part of yourself. Who are you really? What are you made for? What are you here for?"*
>
> *Tony Robbins*

In all walks of life, including career, personal, and business, people talk about the importance and struggles of overcoming adversity. We constantly ask ourselves how we can be better. There is always an emphasis on looking to improve and to be the best we can be. To meet the challenges that come our way, and the changes we implement on our own behalf.

Denzel Washington said,

> *"Imagine yourself on your death bed, surrounded by all the ghosts of the things you never did. They say to you, 'Why didn't you bring us to life? Now we have to go to the grave with you.'"*

Don't be saying *I wish I would have,* because you can, you should, and your time is now! Don't go to your grave with ghosts of things you never did.

In this book, I will use an approach of *shared experiences* from my personal life and career. I will also use experiences of several close friends of mine, and a well-known celebrity. I will discuss just how you can reinvent yourself. My desire is that these stories will resonate with you. The shared experiences certainly helped me on my journey, and I am sure they will help you on yours.

In a self discovery fashion, you will uncover your *why.* In sharing these experiences, you will go on to discover and solidify your specific *what, how* and *when* regarding your own reinvention. The career-related reinvention story will track my exit from the corporate world to when I entered the independent entrepreneur world. I will also share my journey of lifelong habits, hobbies, and sports, and how I discovered new ones, which have become part of my lifestyle today.

I will share insight into what I and others have learned from these journeys, and some of the skills, tools, and knowledge gained. I am hoping a collection of these will be helpful to you on your journey to reinventing yourself. Reasons for reinventing yourself will vary. Just like change, it could be your own idea or forced upon you. Either way, you will use my *formula for success* to ensure your success.

In addition to this, I will address why we feel the need to reinvent ourselves in the first place. And why it is necessary to become different or to change who you currently are. The catalyst for all these changes will be ourselves—the driver in the front seat.

ACKNOWLEDGEMENTS

I am grateful for the challenges that have come my way, the ones I created for myself, and the future ones yet to come. It is in these challenges and the needed changes that we actually grow, thrive, and live our fullest lives! The changes that broke me down were placed in my life so I could build myself back up, stronger each time. Forcing me to continually learn, grow, and experience everything life has to offer. These trials have shown me what sorrow and pain, glory, friendship, love, and happiness are all about. They have brought amazing people into my life, for whom I am forever grateful. I thank those that have always been closest to me, including my Mom and Dad and rest of my incredible family, for their ongoing support, love and friendship.

My thanks to my amazing sons Max and Evan, who have experienced more change and challenges in their lives so far than some people will in an entire lifetime. I admire and gain strength from your adaptability and positivity, and for your ongoing love and support of each other and of me. You bring joy and laughter to our lives.

To Laura. I am so grateful everyday to have you in my life. You bring new meaning to courage, class and confidence. Your unwavering caring, encouragement and love keep me on a continual, amazing journey of punching through my own growth ceilings, continually reinventing myself, while living my very best life.

REINVENT YOURSELF

*Personal, Positive Growth through
any Mess, Movement and Mission!*

INTRODUCTION

Growing up in a middle-class neighborhood in a suburb of Toronto, I heard the word *average* a lot when others referred to me, my skills, and my abilities. I needed *to apply myself more* was a common suggestion my teachers made when my written assignments and test results did not meet their expectations.

Being the third child in my family also meant I had two sets of parents. Allow me to explain, Growing up I had a sister three years older than me, and a brother six years older—voila, my second set of parents! When you're this much younger, the large gaps in your ages are huge. Your older siblings have much different challenges than you, since they are in completely different stages of life. Jumping ahead to modern days for a moment, I will share with you that I had and continue to have an incredibly good relationship with all members of my family. Our total of seven kids also get along with and have supported each other throughout their adventurous lives. People are always surprised when I tell them how positive my relationship with all of my family is, from my incredible parents Joan and Gord now in their eighties and remaining so active, to my brother Larry and sister Lisa. We all meet for every special event possible, especially birthdays, to share laughs and jabs with each other. It is in fact this incredible upbringing that entrenched positive values and sense of self that continually benefit me every day.

Having said this, while growing up I constantly had opinions placed upon me about who I was then, who I should become, what I should be doing, and the inevitable and ongoing question of *why aren't you more like your brother and sister?* I was on an endless pursuit of searching for who I was, and how could I live up to everyone's expectations of me, including societies.

The truth is, I didn't fit the mold society or education had created to showcase brilliance. While I was talented in areas like public speaking and drawing, these were not valued the same, and thus, I had less opportunity to shine. Since I had a weak memory, I was regarded as average in school, since a poor memory was equated to being less intelligent. And let's face it, the way schools graded students back in the day was on their ability to memorize facts, theories, equations, etc. This was not my strong suit.

I regularly fell into the average category, so much so, that my grade eight guidance counselor suggested to my parents that I go into the four-year program, instead of the five-year advanced program. This pigeon-holed me into the path to college, and not university. My parents, not knowing any better, agreed. Should the schools have graded people on other skills than these and allowed alternate forms of self-expression and presentation, I would been considered above average!

Fortunately, I shook this stigma in grade nine, after attending two months of classes, and being incredibly bored with the lack of challenging material. I announced I would be moving up to the advanced level, and thus, the 5-year program. The high school guidance counselor said this couldn't be done. He advised against this. However, this time I made the final decision, giving up half my summer after grade nine, to take the mandatory summer school class to catch up in math. Looking back now, that decision and taking actions for what I wanted, was perhaps the first time I reinvented myself. To avoid facing greater potential failure, ridicule, embarrassment, and pegged for life as *average*, I pushed on. This would not be the last time I would reinvent myself to be who I wanted to be, and to be where I wanted to be.

Einstein said

> "*Everybody is a genius. But if you judge a fish by its ability to climb a tree, it will live its whole life believing that it is stupid.*"

One of my favorite quotes I repeat regularly is from Steve Jobs, who said

> "*Your time is limited, so don't waste it living someone else's life. Don't be trapped by dogma – which is living with the results of other people's thinking. Don't let the noise of others' opinions drown out your own inner voice. And most important, have the courage to follow your heart and intuition. They somehow already know what you truly want to become. Everything else is secondary.*"

Chapter One

HARNESSING THE ENERGY IN CHANGE

Our Brains and Change – Understanding How We Tick

*"Change is never painful.
Only resistance to change is painful."*

Unknown

It was the Greek philosopher, Heraclitus, who first said,

"The only thing that is constant is change."

I know what you're thinking—why start with change? This book isn't about change, it's about reinventing yourself. However true that might be, without change there is no way to reinvent ourselves. Change makes us reinvent ourselves in one way or another. If there were no change, we would become experts at everything that we did since it would be all we focused on.

What is it about change that seems to scare most people and why is change difficult for us? Change is difficult because of how it challenges our thinking. Understanding how our brains are affected will help us deal with change and help us rewire our thoughts to accept and even embrace change. For most people, this difficulty imprisons them to

stay in the position or situation they are currently in. This keeps them from moving forward. Let us have a closer look at some important information on how we as humans address change and reinvention.

Habits Are Stronger Than Willpower

It takes far more energy for our bodies and our brains to reinvent something—anything—especially ourselves! Taking on the unknown, doing something new, and changing ourselves or the status quo can be exhausting for the prefrontal cortex of our brain. The basal ganglia, the habit centre of our brain, is fast and efficient. It will choose whatever is easiest to return to—the status quo—than continually making the effort to do something differently. This is why old habits are hard to change.

What this means, for reinventing ourselves, is that we often mistake habit and fear for resistance and deal with it accordingly. This puts people into a further state of threat and exasperates the situation. As an example, try this experiment out: for one week, wear your wristwatch on the opposite wrist. What you will find, is that even the act of remembering to place it on your opposite wrist, will be hard to remember. What you have just started doing is rewiring your brain. This exercise, like any exercise, will be difficult at first. However, your brain will become better at it over time. Your brain will adjust and improve in handling change.

On January 7, 2019, Paloma Cantero-Gomez wrote the article, "The Top Seven Habits of Mentally Strong People", for Forbes magazine. Paloma mentions that mentally strong people "embrace the unexpected and make the best of it". She goes on to say, "Life can be tough. But focusing on the feeling that *we don't deserve this* will not be of any help. Mentally strong people develop a positive thinking strategy to always find the bright side of life. They do not assume the victim role. They do not focus on finding culprits. They do not compare their miseries with those of others. They decide to grow with adversity and challenge by overcoming obstacles and twisting them to their advantage. They are flexible enough to adjust to the unexpected and accept it as part of the bigger plan."

We View Reinvention Under a Suspicious Eye

As a species, we are still young and evolving, especially our brains. Humans have only been on earth for 200,000 years or so, which pales to the existence of the earth itself, being six billion years old.

Life was fairly simple for us humans 200,000 years ago. Similar to that of a modern-day squirrel, gathering food and ensuring it was not another's next meal, were major priorities. As humans, our number one goal in life was survival. It didn't serve us to be watching a spectacular sunset, admiring beautiful mountain scenery, or be concerned with our happiness. These distractions could cost us our life.

As such, our brains developed a single-minded purpose—to keep ourselves safe. Our brains focused far more on avoiding threat and danger than on pleasure and reward, and this is still the case today. This is further supported by neuroscientist Evian Gordon who states that, "The key organising principle of the brain is to keep us safe".

More simply put, our brain sees change and reinvention, as threats. Our brains crave certainty and predictability—two conditions that change does not guarantee. We are conditioned to avoid threat and when faced with it we display negative emotions such as anger, denial, and fear.

Risk Versus Reward – A Cranium Debate

In business, we often weigh the costs—time and effort—against the potential positive outcomes. We call this ROI, or return on investment. We do the same for any type of change. When we face a change, our brains automatically calculate the reward and the risk involved, in order to determine whether it's worth doing or not. As our brains weigh risk and reward, whichever comes out stronger will influence the direction we take. If we perceive the reward to be less than that of the risk, we are unlikely to engage in the change.

What this means for change initiatives is that a focus on communicating the negative consequences of not changing, aka the burning platform, will be perceived as risky and also continue to hinder us from initiating the reinvention of ourselves, or any other change for that matter.

Success Formula

Many years ago, I came up with a formula for success. This is probably the engineer bubbling up inside of me. It was focused on leadership and business at the time, but I've come to realize that this formula can apply to any aspect of our life. Here is a winning formula for successfully reinventing yourself.

$$(SKILLS + KNOWLEDGE + TOOLS) * GRIT = SUCCESS$$

Throughout this book, we will discuss, focus on, and learn the importance of the elements contained within this winning formula. By learning new skills, gaining relevant knowledge, applying the correct tools, and finally being *gritty*, will ensure your success!

Chapter Two

WHY? DIGGING DEEP FOR YOUR REASON

"We live but one lifetime,
but we can live many lives."

Rick Denley

Clarifying Your Reasons

If your reason for change is weak, and resembles the statement *poor little old me*, you are setting yourself up for failure. The decision to reinvent yourself is not because you hold pity on yourself. Your *why* needs to come from a place of passion, enthusiasm, and even love for the new you!

Simon Sinek wrote a book on finding your why and performed a TED Talk on the subject, as well. During his TED Talk, he discusses how important it is that your *why* not be to create profit or personal wealth. These things may follow but should not be your underlying motivation.

Having clarity to your *why* is imperative for several reasons. One of these reasons includes being able to articulate your *why* to others who will be impacted by you, supportive of you, and even help guide you

during your journey. People will be more supportive of your *why* if they see that it is not just for personal gain. Your *why* will show sacrifice on your part, in some way, shape, or form. But remember that your *why* may be seen as selfish in the eyes of others. Try to start with a *why* that helps others in some way.

Clearly articulating your *why* to yourself first, is key. Once clearly set in your mind, you will not only articulate your *why* clearly to others, you will do so with increased enthusiasm and passion. This, in effect, will sell people on your *why* and gain their interest in your journey. If you have a main circle of people in your life, you will find them wanting to help you achieve your *why* because of how passionate you are to its end goal being reached. Having a solid foundation for your *why* will be extremely important when you get to the challenges and barriers that will surely come your way.

You will want to consider what kind of impact your *why* will have on your life, and the lives of those around you, especially those who are close to you. As you think about your *why*, ask yourself, what has happened in your life to place you on the path to reinventing yourself?

The reasons for reinventing yourself will vary. Is your reason for reinventing yourself your own idea? Who might you be reinventing yourself for? Either way, what is your *why*? It is time to change, adapt, and grow towards your *why*. Stepping out of your comfort zone will allow this to start happening and new opportunities will begin to open up for you.

> *"You only need one reason to succeed, and that's the conviction that you are capable of doing it."*
>
> Robert Herjavec's Driven

Related Story – A Change From My Life's Passion

In September of 2018, I embarked on yet another reinvention of myself. September in Ontario, is a time when the air finally begins to cool off from the summer heat. For those of us 'good old Canadian boys', as hockey legend Don Cherry proudly describes us, we start to think of ice hockey arenas. This is when hockey season begins.

I have a handful of guys who I have played hockey with, on and off, for 30 years. We played our share of league hockey, and local tournaments, including the ball and puck variety. But in these last few years, it was once a week at the same arena in North Etobicoke, Westwood Arena. I had never been a proponent of summer hockey. I was always *hanging them up* at the end of the winter season, which for us was April. However, in recent years, I had kept skating throughout the summer, finding it fun to show up in flip-flops and shorts, and strolling into the far less crowded arena. The boys and I would then enjoy a tailgate beer—these were the best times.

To give you a little background, I played hockey since I was 5 years old. It was therapeutic, to say the least. Now, at 52, I look back on my years of hockey and have enjoyed staying fit this way. There are few things better than hockey to keep you in shape, at least the way I played, which was full out. I didn't know any other way. Sure I may have slowed down a little over the years, but the level of compete was always still extremely high.

Once, my son Evan, walked the length of the bench towards me and my long-time defensive partner and lifelong buddy, Bob. We were sitting between shifts. Evan then applied a stick tap to my shin pads and said, "Hey Dad, it's not game seven!"

He was referring to the fact that, during my last shift, I decided to rush the puck, lean in through the opposing teams defense, and drive to the net. Catching an edge in the process at high speed, I managed to bump the goalie and take the net off its pegs. This sent me, the defenceman,

and the goalie crashing into the end boards in a pile up. I didn't know any other way to play. Intensity is a part of sports, right?

Evan played 13 years of hockey, compared to my 47, but I sat and pondered his words of wisdom. With the sounds of laughter in my right ear from Bobby, who was enjoying Evan's quip, I shouted back to Evan, "Son!" Evan paused and glanced back down the bench at me, as did the others. "It's always game seven!" And so, this is me and sports. One gear, full out, with the mind of a 20-year-old, and a body of a 52-year-old. I felt like I was competing and the Stanley Cup itself were on the line.

What then would make me consider *not* playing hockey this winter season? One reason for this is, that I like change and challenge. I always have. When I was young, I wasn't officially diagnosed with ADHD, OCD, or any other condition, but it was there, and still is today. It is less severe and controlled, now that I've matured, but it is ever present.

With this desire for change and a new challenge, I began looking for a sport, or event, that combined something new for me. I thrived on changes and was always up for a good challenge. Through a very close friend, I heard about a younger guy who started taking classes in Muay Thai at a local dojo. So Muay Thai, better known as kickboxing, tweaked my interest. I had always wanted to learn a martial art, and staying fit was important to me.

I decided to enroll for the free two-week introductory, beginner class. Here I was, in a new environment, surrounded by new equipment, new people—new everything! Change isn't easy. There is no familiarity at all. And yes, of course, I was the oldest in the class! Not by a couple of years, but by a couple of decades! This never bothered me, since I truly believe age is but a number.

The classes were challenging, and the workouts tough. But I enjoyed it very much. So, how does this parley into giving up hockey and then finding myself in a boxing ring? I'm getting to that. Sheesh, you're more impatient than me!

With the common use of social media today and how people now share basically everything they do, I posted about my new venture into this martial art world. In part, this was to publicize the start-up for my new friend, Rob, who headed the classes. And it was also to show everyone that I was taking on a new challenge. I had also begun to keynote speak, and change management was a big topic I could leverage from this experience.

With a few posts on social media, such as Instagram and Facebook, the word was out. Having decided to sign up and pay for a month of classes following the initial two weeks of introductory lessons, I continued to grow and learn. While visiting one of my long-time business associates, interestingly enough, also named Rob, he mentioned that he had seen me posting about Muay Thai. In true Rob fashion, he asked "what the hell is that?

I explained what Muay Thai was, and he began to get excited. This was interesting to say the least. Rob is an interesting character. Having taken over the family company, following the passing of his mother and father, who started it over 40 years ago, he had change forced upon him. So, after his bullish question regarding this newfound sport of mine, he began to share, "Well, if you're doing that kickboxing stuff already, you should consider participating in the fight to end cancer".

Not knowing what he was speaking of, I was still intrigued. He went on to explain, and in a very excited voice added, "I have been sponsoring this charity event where they take people like you, basically white collar workers, who are not professional athletes, and ask them to contribute to the awareness and fundraising efforts. This would entail training for seven months, and then fighting in a charity match at a black-tie gala event. All in efforts to fight cancer!"

Having a goal is always a great way to push oneself. I had always wanted to give back to a charity in some way. In the past, I participated in fundraisers for a variety of causes such as Parkinson's, cancer research, and especially heart-related foundations. I think I could combine a

portion of my newly found sport with a charitable cause—bonus! So, Rob shared more about this event and my interest grew to the point where I agreed to put my name in for becoming a fighter in the fight to end cancer.

Apparently, there were many people wanting to take a punch for cancer. They even held tryouts for this event. I did visit with the founder of the charitable event, Jen Huggins, and went through an interview over lunch. I passed the criteria to join the tryouts, since being semi-fit and well-connected fit the requirements. I also found out later that they had someone wanting to participate for four years now, in his late 40's. This person needed an opponent. The official boxing sanctioned rules meant opponents needed to be within eight pounds and five years of each other. Well, at least the years were within range for us. But I had to jumpstart my fitness regime, so I could make weight.

I began showing up at a boxing gym for conditioning workouts. Jen said to just show up as much as I could during the month of October, and so I did, three times a week. I would have gone more in the beginning of the month, but I could barely hold my hands above my head following the conditioning workouts. Holy crap were those workouts tough! And I thought I was in pretty good shape! It goes to show we are only 'sport specific' when it comes to being in shape. Perhaps it's this way in other aspects of life as well.

After many weeks of conditioning training, massages, and Epsom salt baths, I got the word that I'd made the team! This took a very large level of commitment, including proactively reducing the risk of injury, and exclusively devoting myself to training and fundraising. Seeing the connection now? Yep, hockey needed to be placed aside, for the first time in 47 years, to make this happen.

I've had the opportunity to share about change with my children. And I would tell them, there were really only two types of change. The first is the kind that we as individuals create for ourselves, a conscious decision to do something different, to go in a different direction, and to alter the

things we do now. It also includes how we do things and why we do them in our efforts to change our situation. This type of change creates a self-inflicted accountability. After all, we chose to do something differently. We have a vested interest in seeing it through, regardless of the challenges that present themselves. We own this type of change.

The second type of change involves change that comes our way, but we didn't ask for it. And in many cases, we didn't expect this change to happen. This type of change tends to appear more difficult to us, especially in the early stages. Shock, disbelief, and denial are often responses to this unwanted, unexpected change. How we handle these types of change is the true test. In a word, lead. Regardless of how change comes about, whether it be change we make or change that was inflicted upon us, we must get out in front of it and lead the change. You've heard to accept change, embrace change, but that's not enough! We must lead!

In Jim Collins' book, *Good to Great,* he talks about getting the right people on the bus, headed in the right direction. Further, we need to take the wheel of that bus! Get in the driver's seat and set the direction. Set the course to where you want this change to go, regardless of whether you asked for this change, or if it got dumped in your lap.

We learn through emotional intelligence and that our responses will either be a fight or flight mentality. During my early days of sparring training, coach Virgil was teaching us defence, and we focused on this for a very long time. We learned that our first action of defence, was to use our feet. Basically, run away, or take flight. This was strange to me, since we were fighters, and we were being taught to flee.

When I began sparring, running was not my natural response. While sparring more experienced fighters and taking punches, I would initially stand in and take the punches, while giving some of my own. My natural reaction was to fight. Notice my choice of words, my *reaction* was to fight. When my *response* should have been to flee.

A reaction is an immediate counter to a situation, usually one that occurred because something *triggered* us. A trigger is an identified occurrence that we can recognize sets us off. We all have them. In emotional intelligence, we learn about self, including identifying our triggers, so we can deal with them. Combining my knowledge of self, EI, and coaching, I learned to *respond* to getting punched, and not to *react*. I learned to use my feet, get out of the situation, breath, think, gather myself, and then respond in a controlled, timely fashion. This is a critical skill to be learned by all individuals for all situations whether personal, in sports, or in business.

I was ready to make a change, try something new, become my natural best. It was time for me to fulfill a curiosity I had for many years. Through this journey, I learned to assist in a cause bigger than me, and in doing so, I gave back in a way I couldn't individually. I was ready to support a cause to fight cancer that impacts one in two Canadians and would take the lives of one in four Canadians. I was prepared to combat a disease that took two of my uncles, attacked my mother and sister-in-law, and many others I know. Now, it was time to pursue a new challenge that pushed me beyond my comfort zone. If I remained in this zone, it would age me horribly, and I'd find myself losing my courage, tenacity, and a strong thirst and zeal for life.

Exercise – Your Why

The importance of defining your *why* is vital. Let's take a moment to gather your thoughts on your *why* by writing down a few bullet points on ideas and words that describe your *why*. Let your thoughts flow freely here and write as many words as you need to. We will fine tune them later on in a different exercise.

1. _____

2. _____

3. _____

4. _____

5. _____

> *"Once you understand your why, you'll be able to clearly articulate what makes you feel fulfilled, to better understand what drives your behaviour when you're at your natural best."*
>
> *Simon Sinek*

Only once you've truly identified your *why*—your core passion—can you begin to think about the how. For clarification purposes, and to help you delve further into your own justifications, which deepen your self-accountability, perform this exercise.

Exercise: A Letter to a Friend

I want you to write a letter to a close friend. The letter will share that you are reinventing yourself, and the main reason *why*. Have it contain all the reasons and justifications as to why you are reinventing yourself. Remember to keep it positive, convincing, and heartfelt. Let's get started...

Dear (good friend), I am writing to share something very important with you. I am reinventing myself! I am doing this because... _____

_____.

Related Story – Charity Startup

Anna Mangiafridda Lopes, a business executive for many years, was clear on her *why* when she started a charity to make seriously ill children happy. Anna says "I started Million Dollar Smiles with the simple goal of wanting to bring smiles to children facing life threatening illnesses." She is doing so by building playgrounds in these children's backyards. Her charity also holds an Annual Bear Drive campaign that delivers

four feet high giant teddy bears to sick children around Christmas time. A fund raising program that has grown to include over 200 volunteers. For Anna, it started with one very special girl fighting a terrible illness. Anna wanted to do something to make her happy—to make her smile. Anna's *why* expanded and has become her legacy. Anna made significant, challenging changes in her life to better the lives of others. Anna's incredible leadership and communication skills have proved effective in the charities success. Her legacy now includes showing others how to give back. Anna's mantra is,

> *"You are the richest person in the world*
> *when you can smile."*

To learn more and support Anna's cause, go to www.milliondollarsmiles. ca.

Chapter Three

WHAT? VISUALIZING YOUR END GOAL

You know what you are trying to achieve, become, address or change. You've had it rattling around in your head for weeks, months, maybe years. You have a clear picture of how it will be for you once this is accomplished. It makes you feel warm inside, but with butterflies in your stomach. It brings a smile to your face each time you envision it. You think about it more than anything else on a regular basis. Now that you've decided to pursue your why and shared this with close friends, it is dominating your conversation with everyone! By now, you may have even mapped out some of the steps to this change needed to achieve it.

> *"As humans, we're reading books everyday to try to figure out how to be someone else. What we don't do is go inside, turn ourselves inside out, and read our own story. You have to look inside to find out what you really want."*
>
> *David Goggins*

Related Story – Rick's Vision of His Fight

When training for my Fight to End Cancer charity boxing event, I would often visualize the fight from the time I entered the arena. I remembered doing this years ago when competing in triathlons. The visualization, as accurately as you can make it, prepares you for each moment. It helps

your brain feel like you've already 'been there, done that'. Earlier, we mentioned how the brain is favorable towards habits. These habits become better and better overtime, so the more we visualise each and every moment of getting to our final goal, the more our brain will think that we've already done it!

I envisioned my fight from the time I got to the arena, changed, and warmed up. It continued to who I would give me my pre-fight pump-up speech. What would I feel like once I stepped into the ring? How would I sharpen my focus on my fight and put everything else out of my mind? I had to forget about the music playing in the background, the cheering from my family, friends, and co-workers.

Countless times, I went through my training in my head, thinking up all the different scenarios the fight could bring. How would I respond if I was winning? Or if I was losing, what would my game plan be? What would happen if my game plan changed? Most importantly, I wanted to monitor and control the excitement, anxiety, and everything that came with entering into a major event like this. Visualizing the end result was a major focus of mine. I wanted the referee to raise my arm in victory at the end of the fight. I envisioned the crowd cheering for me, especially the people that came to support me. For someone else to be proud of my accomplishment and witness it was huge. A victory hug from somebody special to me was the ultimate victory. Later on, you will read more about how this event played out.

> *"Set a goal so big you can't achieve it, until you grow into the person who can. Every next level of your life will demand a different you."*

Exercise – Mental Visualization

Angie LeVan, is a resilience coach, speaker, trainer, and writer, dedicated to helping individuals and organizations/businesses thrive! She suggests the following exercise to practice mental visualization:

Begin by establishing a highly specific goal. Imagine the future; you have already achieved your goal. Hold a mental picture of it as if it were occurring to you right at that moment. Imagine the scene in as much detail as possible. Engage as many of the five senses as you can in your visualization. Who are you with? Which emotions are you feeling right now? What are you wearing? Is there a smell in the air? What do you hear? What is your environment? Sit with a straight spine when you do this. Practice this at night or in the morning, just before and after you sleep. Eliminate any doubts, if they come to you. Repeat this practice often. Combine with meditation or an affirmation.

"I am courageous; I am strong,"

To borrow from Muhammad Ali,

"I am the greatest!"

Part One: Descriptors

With your knowledge of the power of visualizing your end goal, your task is to write out exactly what a successful end to your journey would look like. Make use of the exercise from Angie and complete a detailed account of your end goal.

Now that this clear to you, repeat this visualization in your mind often. This will sharpen important details and boost confidence along the way. Look at your descriptors often.

Part Two: Vision Boarding

Vision boards, also known as dream boards, visualization boards, or action boards are essentially compilations of what you want in your life. What do you want to achieve, experience, have, or feel? Many people make their vision boards annually, in order to stay focused on their goals for the next year. These boards usually consist of pictures and words, and have a collage look and feel. We will focus on a vision board specific to your end game reinvention.

Many vision boards also incorporate words into their motivational masterpieces. Some advocate for including dates on vision boards to help you give yourself a timeline to stay focused. You can put the year at the top and/or months and years with each item on your board. Describing each item in a word or a few words is also a very common practice. As is placing a title that captures your goals, for example 2nd Career Comeback, charity program, gold medalist, champion. The things you put on your board should be the end result that you are aiming for, but you can also include imagery that reflects the steps required to get there.

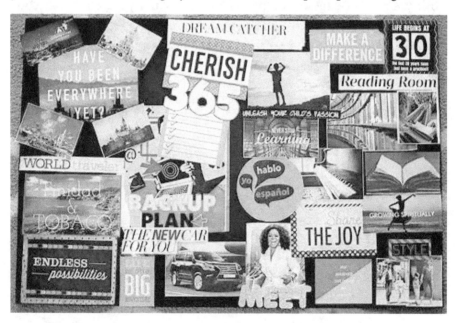

Take the time to create your own vision board. Have fun doing so, and even include those closest to you. Discuss your reinvention and the vision of your outcome at the end of your journey. Finally, display the vision board where you see it often. Take the time to look at the messages and items you've placed on it and believe that you are achieving them towards your final goal.

Chapter Four

HOW? ACTIONS TO REACH YOUR WHAT

"The pathway to success is to take massive determined action."

Tony Robbins

How you will reinvent yourself will vary depending on many factors. However one factor is essential, action! I had the opportunity of being surrounded by many incredible individuals over the past few decades. I've observed many people and this has given me insight into the quintessential set of characteristics, skills, tools, and approaches necessary to reinvent yourself. This also lends itself to reinventing yourself efficiently, and in the quickest, most fulfilling way possible. Strengthening these individual characteristics and learning to apply these tools is key. Be proactive in gathering the support you need, and in applying 'stickiness', the ability to stay the course when challenges and barriers rise up during your journey, which we will address in a later chapter. This will help ensure your success on your chosen desired outcome.

When I reached out to people I admire, I asked them to share their journey with me. I looked up to them for many reasons, including the

way they changed and reinvented themselves, whether out of choice or necessity. One of the things I was interested in discovering were the characteristics they felt helped them be successful. I will go on to share these in this chapter in an effort to help you understand how you may want to strengthen these 'success characteristics' within yourself to help you reach your goals.

Actor and musician Will Smith said it's the hours and hours and hours of effort that takes whatever talent you have and translates that into skill, no matter how talented you are. Smith once told an interviewer,

> *"Your talent is going to fail you if you're not skilled, if you don't study, and if you don't work really hard and dedicate yourself to being better every single day."*

Adaptability

We must strongly consider adaptability, because it directly relates to those impacted by change. This is change that has 'been done to them'. Change came their way without them wanting or asking for it and imposed itself on them. Adaptability was required and they responded well. Adaptability is defined as a quality, more than a characteristic.

> *"Adaptability is the quality of being able to adjust to new conditions. The capacity to be modified for a new use or purpose."*
>
> *(Wikipedia)*

Whether a quality, characteristic, or skill, it is essential to be adaptable when change comes our way. It is not enough to only accept change. Nor is it enough to embrace change. We must learn how to adapt ourselves to all situations, including the ones we choose and those chosen for us, and lead change.

Dr. Shimi Kang, MD, is a Harvard-trained Canadian psychiatrist, researcher, author, and speaker. She currently has a clinical practice in Vancouver, Canada. Her area of research is in the neuroscience of success. Dr. Kang is an expert in motivation and wellness—along with the science behind it. As part of a research study, Dr. Kang interviewed a large number of elderly people. These were people who felt they had lived an awesome life.

What do you believe was the one skill they all demonstrated? Correct, adaptability!

Adaptability creates more happiness and overall life satisfaction. According to Guy Winch, a Ph.D. licensed psychologist, and author of *Emotional First Aid: Healing Rejection, Guilt, Failure, and Other Everyday Hurts,* there is so much we stand to benefit when we are willing to adapt. One of the most prominent ones is more happiness in life. "We will always be confronted with psychological challenges in life. Some, after waves of hopelessness, take a bow. Some courageously take on these setbacks, learn whatever lesson life gives them, and then they move on with life. One fact we can't deny is that our happiness, satisfaction, and ability to build a quality relationship is largely dependent on our adaptability skill."

Adaptability helps you stand strong in a seemingly hopeless situation. Once you assure yourself that you have all it takes to begin the change process, right within you, you will have already unlocked more happiness for yourself. And happiness may be one of the reasons why you endeavour to reinvent yourself! Being able to adapt to changes in our lives ensures that whenever life knocks you down, bouncing back will become easier. Remember how we discussed how we can rewire our brains, so good things becomes habits?

There are times we experience unexpected and unpleasant situations in life. Being adaptable ensures that you will stay afloat when the adversities of life try to sink you down. Instead of running away from reality, you need to embrace it, flow with it, and get out front and

lead it. Adaptable people are resilient people. Dean Becker, an expert in resiliency, believes that our success in life is built on our ability to adapt. He went on to say, "An individual's success isn't dependent on their level of education, intelligence, or experience. It is their level of resilience that really matters. This is true in sports, medicine, business, and personal life."

Adaptability expands our capacity to handle change, no matter how serious it might be. Instead of throwing away your energy trying to change your circumstances, change yourself from within. This will make you thrive in whatever situation you find yourself in. How adaptable we are has a lot to do with how strong our emotional intelligence is. How well do you have control over your emotions and reactions? Better yet, how do you respond to difficult, unwanted situations? A strong EI/EQ lends itself to a strong adaptability quality. Seek ways to measure, understand, and improve your EI/EQ, especially if you are choosing to reinvent yourself when you did not anticipate doing so.

My final word on adaptability is to focus on others. You may have to help others adapt to the changes and the reinvention of you. It will not come easily for them, and you will need to be patient with them. You will also need to be steadfast and firm. These changes are your desired state, and no one gets to decide how or who you should be. For this, there can be no discussion!

> *"You cannot dream yourself into character.*
> *You must hammer and forge yourself one."*
>
> *Henry David Thoreau*

Related Story - Rick's Story of Business

It was during the early months of 2008 that I decided to take on a huge challenge in my career. I signed on for a general manager's role in a small automation integration firm with a staff of 15. I had previously worked for large, multi-national organizations, but this was my opportunity

to move my career and learnings forward in an all-encompassing role as a GM. This firm was focused on the automotive industry and had been very successful for several decades. Unfortunately, the owner who had built the business and actively stayed engaged with it through its growth, passed away a year earlier. The widow had been involved in the business to some extent and was running it with the assistance of some long-time senior staff members. I was brought on board to bring the organization back to profitability.

As it turns out, only weeks into me taking the lead role, the economy went into its deepest recession in decades. The automotive industry was hit the hardest and this company felt the downturn very hard. Needing to have the company adapt to these unforeseen changes, I put a plan in place to create a new revenue stream in the services-related sector. Applying my transferable skillsets helped this new strategy and reinvention of the company as it began to become profitable again.

Getting other key personnel in the organization to adapt to the new direction took a tremendous amount of EI/EQ. Understanding their personalities, communication styles, and what drove them was crucial. Taking the time to learn the individual characteristics of each member, ensuring each was addressed in a way that would allow them to buy-in and help drive the reinvention, was essential to its success.

Soon following this turnaround, we decided to sell the company and we were able to attract a competitor whose client offering lacked what we created in our services area. Instead of competing, they chose to buy our company. When reinventing ourselves, we took along some of our skillsets that were imperative and helped others adapt to the reinvention. Keep in mind that different people adapt to new circumstances and ideas in different ways and at different rates. Encourage others, and lead by example. This will create a positive environment for people to adapt to change, and embrace and lead the reinvention.

Commitment / Dedication

"Commitment is a psychological state that is demonstrated through your actions."

If you want to succeed at anything, you must commit to it. We are told it takes 10,000 hours, the equivalent of ten years at a full-time job, to become an expert at anything. The 10,000 hours theory comes from Malcolm Gladwell's book, *Outliers*. In his book, Gladwell expresses the concept of 10,000 hours in a number of ways. Gladwell never says that it takes 10,000 hours to become really good or an expert. He simply implies that 10,000 hours of practice, results in what we would consider a genius, master, or an outlier.

A tremendous amount of commitment is required to reach any goals we set, if we set them high and big enough. For me personally, commitment is not taken lightly, especially when others are aware of your goals. So, why do we commit to something? I believe the main reason is because we want to be successful. In my case, this venture into something new, the sport of boxing combined with raising awareness and fundraising for cancer, required my full commitment. But, I still needed to make a living and balance my human needs of love and companionship.

So, how does one become committed? Commitment often involves the aforementioned 'change'. We need to change things we've done in the past to achieve new and different things in the future.

"If you always do what you always did, you'll always get what you always got."

So, we change. To be successful in this change, we need to commit to it and all it brings us. They say it takes 21 days to form a new habit. How do we make it through these 21 days? We commit to it. For my personal journey, I committed to fight to end cancer. It involves training, fundraising, and awareness building. Part of my commitment involves change. No longer would I play hockey with the guys. Between

the intense workouts ahead of me, being both physically exhausting and time-consuming, I couldn't risk the chance of getting injured playing hockey.

Truthfully, I had a better chance of getting injured boxing, than skating with the boys once a week, but so be it. I committed. In doing so, I began the campaign of awareness for this cause, and this furthered my commitment. Placing it on social media and sharing the details with my closest friends and family meant I was all in. Fully committed. This wasn't a whim, or a fleeting idea. I was committing myself mentally, physically, and most importantly giving my time. This commitment would take precious time from my family, friends, and work. Now, that is a commitment.

So, what do you do when you're embarking on something that will inevitably impact every aspect of your life? You communicate this commitment. Write down your goals and your future achievements. Not being a tremendously religious person hasn't stopped me from having faith in my journey and being spiritual. When you are dedicated, create a plan and act towards your goals. Put all of your positive energy towards them and the universe will have no other option but to conspire with you to make things happen.

Related Story – Breaking the Chain

During my boxing training I met a true champion, Dillon "Big Country" Carman. Dillon was born on June 15, 1986, near Belleville. This is a small, rural town in Madoc, Ontario with a population of 1300 people. Sherri Carman, Dillon's mother, raised her son and daughter, Rebecca, on her own. Dillon's upbringing was far from great since life as a single parent is tough. But Dillon explains how grateful he is now and attributes being happy to his mother's attitude and teachings. He was surrounded with drug addiction, depression, abuse, and bullying within his extended family and neighborhood in which he grew up in. But Dillon was determined to be different, and not follow in the ways

of others around him. He was determined to break the cycle. His mom wanted to change the negative stigma of their name he had inherited.

From a young age, his mother gave him a positive outlook. She shared how to look at people from a different perspective. Dillon focused on being a good person, and on his love of sports. He received a hockey scholarship to Florida at 15 years old, and he took this opportunity to advance himself. Dillon lived there for five years, dry land training with a boxing club, and this eventually became his future. He shared with me how his mother's positive attitude and teachings of respect developed confidence within himself. This led to understanding the importance of commitment, which in turn helped him to reinvent himself from the gloomy future mapped out for him. Dillon's commitment continues today to his boxing career and his family, including his beautiful niece.

"People don't understand how strong minds make us happy. At the end of life, you have memories and regrets. You want your memories to outweigh your regrets."

Dillon Carmon

Communication

"The single biggest problem in communication is the illusion that it has taken place."

George Bernard Shaw

Communicating your change and commitment can be easy. Tell those around you what your intentions are and get started! Done! In fact, with social media, a few clicks should have everyone well-informed. However, remember that not everyone is on social media. And you may be including some people you don't want to include with your initial sharing's. My parents, as technologically savvy as they are for being in their eighties, do not partake in social media—at least not yet! And because of this I've gotten myself into trouble on occasions. You see, I

have two young adult children, who are active on social media. When situations occur, whether good, bad, or celebratory etc., they announce these on social media very quickly. For those of us on social media, we see these updates almost instantly, and are thus informed ina timely fashion. For those who are not on social media, they don't get these messages right away. Here's where the problem occurs in regard to my parents.

When one of my sons was accepted to a university, he posted the news on his social media immediately. His cousins picked up on it, who in turn told their parents. And my mom found out from somebody else, other than me or my son. This, in her eyes, was incorrect. She strongly believed that this kind of news should have come directly from me. I tried to explain how difficult this was now, with social media so prevalent today. It wasn't enough for her to want to be on social media, but she made it very clear that, in the future, news like this should come to her directly. She should not be hearing about it from a second or third-hand source. So, even though different generations might be using technology, they still hold true to their old traditions and we need to adjust and adapt to whatever that is.

There are many reasons to communicate properly, beyond just strengthening your commitment publicly. Proper communication shows you care about the topic you are sharing. Proper communication ensures those around you fully understand the message, its impact on you, and the potential impact on them, too. Common communication will not suffice. For this incredible endeavour, we'll need breakthrough communication!

Things to keep in mind for breakthrough communication:

- Before any conversation, try to identify as many potential differences in definitions, experiences, and perspectives, which might lead to difficulties or misunderstandings later on.

- Listen carefully and thoroughly to what the other person says in response to you and have them do the same. Often, we are so focused on what we will say next, we don't fully listen to what the other is saying to us.
- Ask questions when you think they might have misunderstood you. For instance, "Did that make sense?" or "Was I clear in how I shared that with you?"
- At each logical step in the conversation, have them repeat back, in their own words, what they think they heard you say.

Communication is very important to interpersonal discussions when you share what you are intending to do in reinventing yourself. Communication is how we move ideas from person to person. When communication goes awry, part of the idea is lost or misunderstood. The other person thinks they have the idea, but in fact it is, at best, not quite right and at worst, it can lead to something tragic.

There is an illusion that communication has occurred, but in actuality, it has not. Both people think they understand what has been passed between them, but the ideas they have are not the same. This is where the illusion of communication can be most damaging.

As humans, we need to transfer ideas from one person to another on a regular basis. Communication is the word we use for that transference. Often, miscommunications are due to differences in experience or differences in definitions between the persons involved. If a parent asked their child if their room was clean, does the parent and the child have the same definition of clean? Not likely.

If you find your listener is more visual, use drawings to share your story and what you are trying to communicate. For some, charts, pictures, and diagrams will be better understood and remembered than just words.

Think about the circle of people you will communicate with. Be sure to cover all those involved and whomever will be impacted by your journey. It's easy to think of your family and friends, however we must also think about colleagues who will be impacted, such as our bosses or work personnel. Our reinvention may require:

- time off
- grace for being late
- patience if we are a little off
- questions answered if they possess the knowledge we are seeking
- support for things not work-related

Related Story – Moral Suasion

During the early stages of my sports reinvention, I needed to share what I was about to embark on very clearly to those around me. I communicated my commitment and intentions with such enthusiasm and passion. My circle of people not only understood what I was sharing but bought in with full support. Those I shared with understood the downsides, the challenges, and the impact on them. They also understood the upsides for me personally and the cause I was supporting. They decided to rally around me with tremendous support. In some cases, they participated when and where they could.

Back in the 1990s, I worked with an organization called Emerson. Emerson is a global organization based out of the USA. Emerson had a shared services type of business in different countries, including Canada, where I was a divisional manager. I reported to the president of North America, who was based in the USA. The shared services arrangement allowed different divisions, including mine, to be housed under the same umbrella of services, including human resources, finance, legal, and logistics.

The organizational structure was such that one individual gave leadership to these shared services in each of the countries they were

present in around the globe. For Canada, a gentleman named Larry Barrett led these services. Now, Larry was older and more mature than most of the divisional managers, including myself. Larry's job was to provide these services to managers, and also guide and mentor them. On one of the trips I took across Canada, to attend national meetings, I took the opportunity to have a discussion with Larry. I wanted to know how he was able to get buy-in from all the different managers under the Emerson roof. They always supported the initiatives that he created. Larry had a great attitude and an inspirational way about him. He laughed when I asked him this question and had a slight smile on his face. Then, he nodded his head a few times, waved his finger in the air and said only two words, "Moral suasion."

I looked back at him with a puzzled look. I repeated what he had said in a questioning manner, "Moral suasion?" He continued laughing, so I asked him what moral suasion meant. He went on to describe to me what it was, in his words. Moral suasion is the ability to get people to come around to your way of thinking and to support your decisions, without needing any authority imposed on them. It was basically having very good negotiating and convincing skills, without needing to be a bully or authoritarian. This is what author and leader, Robin Sharma, calls *Leading Without a Title*. Keep Larry Barrett's' approach and character traits in mind when you are communicating to others in your inner circle about your reinvention, and don't forget to use your moral suasion.

So, who will be the important people you need to share and clearly communicate your forthcoming reinvention journey with? And who should you share with first? Let us take a moment to not only give some thought to these important individuals, but to prioritize them in order of who to tell first, second, and so on. Here is a sample that can give you a jump start and some ideas. Take time to make it your own:

Priority Order	Who	How/When
High	Spouse/Significant other	Over dinner and a glass of wine (or two)
High	Best friend(s)	Over coffee
High	Parents/Children	Family meeting
Medium	Work-related, boss, and peers	End of the next team meeting
Low	Wider network of friends	Social Media

Communicate. And repeat until everyone involved has bought in and fully understands the reasons, the impact, and the goals of this commitment you are communicating specifically to them.

Passion

"Passion is energy.
Feel the power that comes from
focusing on what excites you."

Oprah Winfrey

The secret to outstanding achievement is not talent but *grit*. Grit is a special blend of passion and persistence.

We mentioned how when communicating a message, doing so with passion makes the message far more impactful. Passion is contagious. When communicating your message with passion, it will be better received. Passion is the key to completing challenging tasks. Nothing challenging was ever successfully completed without passion.

How does one generate passion? Where does it come from? Can we truly share passion with others? Passion for me comes in the form of something that energizes me. To take on any major change or challenge, you need passion. Mega amounts of self-generated passion! The fight to end cancer created a passion inside of me. It was one strong enough to see me through the challenges I would face. If you have chosen your *why*, your passion will exist within you.

Angela Duckworth, author of *GRIT*, shares her description of passion:

> "What I mean by passion is not just that you have something you care about. What I mean is that you care about that same ultimate goal in an abiding, loyal, steady way. You are not capricious. Each day, you wake up thinking of the questions you fell asleep thinking about. You are, in a sense, pointing in the same direction, ever eager to take even the smallest step forward than to take a step to the side, toward some other destination. At the extreme, one might call your focus obsessive. Most of your actions derive their significance from their allegiance to your ultimate concern, your life philosophy. You have your priorities in order."

Related Story – Rick Entering KBC

When entering the Kingsway Boxing Gym for the first time, I felt the fighter's passion. I saw it. I smelt it. I wanted it! This was not a fashion show gym. People were not here to find a mate or impress someone next to them. These people were passionate about one thing, fighting! I hadn't felt this type of passion in a very long time. The last time I recall this type of passion would have been when I traveled to Niagara to watch my son, Evan, play Junior A hockey. Prior to the game, I saw him in and around the dressing room. The intensity, the focus, and the passion for their sport was evident.

With my other son, Max, I attended a transgender march and rally. I had the opportunity to listen to him and other speakers share their stories and journeys. The people who gathered gave me the same sense the speakers did, passion. Think about experiences you have had where the passion for the cause was so evident in the people involved? That is the passion I was engaged in with members at this gym, this journey, including those dedicating their time, and in some cases, their blood! and tears, too. I soon realized this passion was from the top down, coming from the leaders and organizers of the cause, who also happened to be the coaches and owners of the gym. Passion can be transferable to others around you.

How will you communicate your passion to others? Here are some reminders when sharing your journey with passion:

o **Use stories to engage their feelings.** Tell stories that have inspired you to make these upcoming changes. Use the stories to illustrate a point or make something abstract, more concrete. The stories could be about what led you to this reinvention of yourself. In talking about yourself, you will recapture your own passionate feelings and communicate these feelings to your listeners.

o **Prepare mentally and physically.** You want to be well-rested and in good shape so that you are energetic and enthusiastic when you share your news. Your body language and posture show excitement, or any lack thereof. Stay totally present and give everyone a warm confident greeting.

o **Display physical energy.** Use gestures when you talk. If appropriate, move while you speak. Now I am not suggesting you look like the blow-up advertising guy, flailing his arms and body all over the place at a local car dealership, but energetic movement of your hands within your personal space adds excitement.

- ○ **Vary the pitch of your voice**. It is important to avoid being monotone. Passionate people are excited and so their voice naturally goes up and down.
- ○ **Smile as you speak**. We teach sales people to smile when they conduct business over the phone. And they always ask, "Why would I be concerned about smiling when the other person on the phone cannot see me smiling?" We share that, although they cannot see the smile, they can hear the smile in your voice. Look for joy in whatever you are doing or talking about. Then show the pleasure and happiness you feel in speaking and sharing this news with others. Sometimes initiating the smile brings joy.
- ○ **Use variety in pace and an overall upbeat tempo.** Keep your speech pace upbeat, speaking slower for emphasis, and then faster for energy and excitement.
- ○ **Keep the volume of your voice up.** You want everyone to hear you. This also helps you to realize the importance of what you are saying.

"When a fighter walks into a boxing gym with a spark of interest, as a coach, you feed that spark, so it becomes a flame. You feed the flame and it becomes a fire. You feed the fire and it becomes a roaring blaze."

Virgil Barrow
Owner and coach at Kingsway Boxing Gym

Lifelong Learning and Improvement

The studies of and implementation of emotional intelligence and emotional quotient has become integral in not only leadership roles, but in our own everyday life.

What Is Emotional Intelligence/Quotient?

Psychology Today refers to EI and EQ as an "ability to identify and manage one's own emotions, as well as the emotions of others. Emotional intelligence is generally said to include at least three skills: emotional awareness, or the ability to identify and name one's own emotions; the ability to harness those emotions and apply them to tasks like thinking and problem solving; and the ability to manage emotions, which includes both regulating one's own emotions when necessary and helping others to do the same."

"There is no validated psychometric test or scale for emotional intelligence as there is for G—the general intelligence factor. Many argue that emotional intelligence is therefore not an actual construct, but rather, a way of describing interpersonal skills that goes by another name. Despite this criticism, emotional intelligence or emotional quotient, has wide appeal among the general public."

The four main areas of Emotional Intelligence include:

Self-Awareness: The ability to recognize and understand your feelings and emotions, and the ability to understand how you respond to situations and other people's actions.

Self-Management: The ability to choose how we express ourselves, to control our thoughts, feelings, actions, and to motivate ourselves. Self-management is also referred to as self-regulation.

Social Awareness (others): The ability to recognize and understand the feelings and emotions of others. This includes skills in empathy.

Relationship Management: The ability to express your emotions and communicate effectively. This allows you to manage relationships with others and manage how they might respond to you.

Why is EI important for us when reinventing ourselves?

Having a strong EI, and understanding of your EI, will assist you in the way you respond to life events, such as change, and manage your response to the events. It's not what happens that matters, but how you respond to it that really counts.

Emotional quotient gives you the ability to distinguish between the event that happens, and the way you respond to it. Simply being aware of your response means you can make changes that benefit you. Being emotionally intelligent is the underlying structure, the foundation, that supports effective responses to events, people, and change.

Related Story – My EI Learnings

During my boxing training, understanding my triggers and having control was imperative. Discipline is extremely important in training for anything, and more so in the ring. EI/EQ is something we can work on and improve. This is unlike IQ, which is fixed, although we do gain knowledge and skills over time.

So, how does someone demonstrate their EI/EQ? Well, it certainly wasn't the way I handled myself on one occasion during our sparring rounds with teammates. On this particular occasion, I was sparring with my teammate. This particular teammate is eight years younger than me, several inches taller, and about 50lbs heavier. The thing we have in common is our reach, both having long arms. Unfortunately, what we also have in common were short fuses when in a fight or flight situation.

Getting punched in the face is never fun. During sparring, we are instructed in which punches we are allowed to throw and at what intensity. For example, on this day, our coach, Virgil, instructed us to use 1's and 2's, also known as jabs, with our left hands, and crosses, with our rights, and both at 50% intensity. The idea was to work together to get better, always emphasizing defence over offence.

My opponent spares with intensity and always comes forward, with little give and take. During this session, he kept coming at me, as we exchanged jabs, and the occasional cross. His intensity ramped up quickly after I landed a couple of jabs to the top of his forehead, a spot which we aim for. I had learned early on that my reach, accuracy, and speed of my jab were an effective combination. I could land them on most opponents, including more experienced boxers. Doing so with this teammate, even at 50%, angered him. His anger ramped up quickly and he began throwing many punches, with an intensity that was increasing towards 100%!

My EI triggers were lit, and I reacted instead of responding. Ducking one of his hooks, a punch we weren't to be throwing, I countered with a hook to the side of his head. As he stumbled back a bit towards the ropes, I kept stepping closer throwing more punches, admittedly heavier than 50%. As coach Virgil, out at ringside, was observing us, he began yelling at us to break it up. My opponent and I were throwing uncontrolled, haymaker, ugly punches with little control. Realizing coach Virgil was extremely upset and that this wasn't the exercise we were instructed to have, we finally pushed off of each other ending the fiasco. We were kicked out of the ring and received a strong tongue lashing from our coach, which let me tell you, was given with tremendous passion! What had happened here? Simply put, we lacked control of ourselves, and control of our EI. We reacted, instead of recognizing and properly responding to our emotional triggers.

Fearless

No one is fearless. We all have fears of something. Fears can be described another way. We can describe fear as being barriers to getting to where we need to be or want to go or who we want to become. Learning to identify what our fears are will help us understand how to overcome them and deal with them. Perhaps we will never become completely fearless but understanding and managing our fears will make us less fearful. In the next chapter, we will provide you with the necessary knowledge and skillset to address your fears.

Ignoring fears is not a healthy option and will throw up impenetrable barriers, as will inaction.

> *"Inaction breeds doubt and fear. Action breeds confidence and courage. If you want to conquer fear, don't sit home and think about it. Go out and get busy."*
>
> Dale Carnegie

The flip side of fear is courage.

> *"Most of us have far more courage than we ever dreamed we possessed."*
>
> Dale Carnegie

We will discuss times when you've been courageous in the past, and harness these to assist you in the journey to reinventing yourself.

> *"It is often asked how some people find their courage. Perhaps we haven't been given a choice."*

Focus

Quiz time: How long is the average person's attention span? More or less than a gold fishes?

According to a 2015 study from Microsoft, the average person's attention span is eight seconds less than that of a goldfish. This number has shrunk over the years due to our digital connectedness and the fact that the brain is always seeking out what's new and what's next.

"No matter what environment humans are in, survival depends on being able to focus on what's important–generally what's moving. That skill hasn't changed, it's just moved online," writes Alyson Gausby, the consumer insights lead for Microsoft Canada.

The difficulty nowadays with focusing, is how many things we try do at once. And how well, or poorly, we do several things at once.

Here are some tips, tactics, techniques, and suggestions to help you focus on any task.

1. Log out of email and social media a half an hour before conducting a task you wish to perform. Stay off of your devices for the duration of your task. You'll be amazed how much you can get accomplished when not being constantly interrupted, even by yourself.

2. Play some appropriate music to drown out any background noise. According to a study from the Wake Forest School of Medicine and the University of North Carolina, having music playing helps you focus on your own thoughts. Just ensure you like the songs.

3. Take short breaks. In a study from the University of Illinois, psychologist, Alejandro Lleras, found that participants who were given short breaks during a 50-minute task, performed better than those who worked straight through. This phenomenon is called *vigilance decrement* or losing focus over time. Taking a short break in the middle of a long task reenergizes the brain.

Lleras writes,

"We propose that deactivating and reactivating your goals allows you to stay focused. Our research suggests that, when faced with long tasks, it is best to impose brief breaks on yourself. Brief mental breaks will actually help you stay focused on your task."

4. Doodle. Yes, my grade schoolteachers who always got so frustrated by me doodling on my papers during their long and boring lessons were wrong! To improve your focus during long

meetings or lectures–use your artistic skills–doodle! According to a study from the University of Plymouth in England, doodling aids in cognitive performance and recollection.

"Doodling simply helps to stabilize arousal at an optimal level, keeping people awake or reducing the high levels of autonomic arousal often associated with boredom," writes lead researcher Jackie Andrade.

Related Story – Eye of the Tiger

"Nothing is going to change for the next hour, so focus on the task at hand." I repeated this to myself and to training partners when we entered the gym to train. We needed to be 100% laser focused. We weren't just working out for the sake of working out. At some stage, we were going to spar opponents and our physicality would be at risk! We all have distractions. Things on our minds, things we are responsible for and interested in that don't simply go away.

When it was time for training, I turned off my phone during the drive to the gym and played music. This was usually my self-created fight soundtrack. It was full of pump-me-up music that put me in the Rocky state-of-mind. And yes, "Eye of the Tiger" was one of the songs. I put in my wireless earbuds, which was a set by Bose, because I liked the extra base they provided to get my heartrate thumping to the beat. Warming up to my music felt the best for me. The phone stayed in the bag until the end of the workout. No distractions to be had. We were even taught a technique where we allowed our eyes to go slightly cross-eyed. This made everything a little fuzzy, and your mind could drift a bit from what was directly in front of you. This was especially effective when shadowboxing.

A well-known athlete, Tiger Woods, has been a model of demonstrating incredible focus. It is said that Tiger Woods never slept for more than two or three hours a night. A typical workday started every morning at 6:30 and extended more than 12 hours. Through three workouts,

two range sessions, two practices on the putting green, one short-game session, and two nine-hole practice rounds, the day ended with dinner at 7:00 p.m. Day after day after day, this was Tiger's routine. His focus was so intense that he would regularly experience self-described blackout moments on the course. He could not actually recall hitting many of the shots that everyone else remembers him hitting. He would regain consciousness only as his back finished its rotation and his hands came to rest just above his left ear, with the ball rising into the distance.

To put his crying newborn daughter to sleep in the middle of the night, Tiger did not simply rock her while watching TV. He has described carrying the infant to the gym in his house, situating himself on the leg press machine with her on his lap, and doing 600 repetitions until she had fallen asleep. His only documented outdoor pastimes, other than golf, were spearfishing and free diving, which is swimming at great depths in the ocean without the benefit of an oxygen tank. Nothing about his life was ever done halfway. Whether it was the lifting, the cardio sessions, or commando training sessions with the Navy SEALs.

From: <https://www.espn.com/golf/story/_/id/8865487/tiger-woods-reinvents-golf-swing-third-career-espn-magazine>

Faith

Related Story – Growing up without (a) faith

Growing up in a suburb of Toronto during the 1970s, the predominant religion was Catholic. Now, I wasn't religious in the least. I vaguely remember saying grace at the dinner table, but only during calendar events such as Thanksgiving, Easter, and Christmas. In school, we recited the Lord's Prayer until I moved onto a new middle school, Dixon Grove. Here, the morning routine was the national anthem.

I do remember attending Sunday School. I was separated from my parents and older sister, Lisa, to go be with the other younger kids in the basement of the church. I don't recall my older brother, Larry, ever

attending church. But this doesn't surprise me. As we still joke today, Larry has a halo as the oldest and most revered in our family, and he always got his way from a very young age. Now don't misunderstand, I had and still have an amazingly positive relationship with my siblings, for which I am so grateful.

The following years, I rarely saw the inside of a church unless I was attending a wedding or baptism. In fact, I had such a poor understanding of religion by the age of ten, that when asked, I insisted to a police officer that my religion was *Canadian*. It was an odd incident that occurred at the local small strip mall in my neighborhood. I rode my bike there to hang out with friends, grab a freeze, and chat. The police rolled up on our group of ten-year-olds, cornering us, and telling us we were in trouble for loitering. I didn't even know what loitering was.

They began asking us for our names, addresses, and very strangely, religious backgrounds. Not knowing any better, I insisted I was Canadian. Looking back, I am saddened by my lack of knowledge of religions and cultures. This changed immensely in my teenage years when my close group of friends evolved to include many diverse cultures and corresponding religions.

Up until the past couple of years, I am embarrassed to say that I still had a misunderstanding of the term faith. I incorrectly believed faith was a blind worship of a religion. To blindly follow something and not challenge it. *Just have faith and it will come true.* Little did I understand that faith can have different contexts. Faith as a characteristic towards supporting your journey is about having faith that the things you do *will* place you on a path to where you want to be, and to what you want to achieve.

When looking up the definition of faith, for clarity, I found that it had two definitions. One of which is religious-based, so, perhaps I wasn't too far off with my own definition.

A strong belief in God or in the doctrines of a religion, based on spiritual apprehension rather than proof.

The second definition is essential during your reinvention journey.

Complete trust or confidence in someone or something.

Without faith, we can't expect that things will turn out all right for us, no matter what the situation might be. In strengthening your faith, you are strengthening your resolve.

"Every obstacle yields to stern resolve."

Leonardo da Vinci

Embrace Uncertainty

> *"I tell people that the quality of your life is in direct proportion to the amount of uncertainty you can comfortably live with. If you want to be certain about everything every moment, then you can't do something new, you can't grow." Tony Robbins*

If all challenges of change and reinventing ourselves, came with an iron clad guarantee, everyone would do it. There are no guarantees when you are taking a leap or when you are embarking on BHAGs or big, hairy, audacious, goals. You, in fact, cannot be safe while advancing on the bags in baseball. And this applies to any major change for advancement in your life. There is a period when you are out there, right in the middle of 1st and 2nd base. In limbo. By yourself. Hopefully, looking forward at your goals, your 2nd base, and not back at the safety of first base. In fact, once you've gone halfway, even a quarter of the way, there can be no going back. It will be as if the umpire took 1st base away the minute you headed for 2nd. You need to embrace some uncertainties as a good thing, not a scary one. Getting used to new feelings takes time.

There are strategies for minimising threat and increasing certainty in change. Acknowledging that change is hard for those around you is helpful. It is likely that by the time you come around to communicating the details of the change you are planning others will have already seen it coming.

Communicate, communicate, communicate! Our brains are prediction machines and with half a story at hand, our brains will want to close the loop. While I was a senior manager during the 2001 internet boom and bust, we held daily conference calls with the entire company, even if there was no new news to share. We also held daily Q&As where no question was off limits. We did whatever we could to address any lingering questions before potential issues got out of hand. We wanted to fully support our staff since they deserved this from management.

According to McKinsey & Company, the 70%-80% failure rate of change initiatives today has not fluctuated since the work of John Kotter in 1985. When we take the brain into account, aim to reduce threat and uncertainty, and hyper-communicate, we are giving ourselves and others the opportunity to support each other's success.

> *"You cannot keep your foot on first base, and still steal second. At some point you must be out there, where being safe is not a guarantee."*
>
> *Unknown*

Related Story – From Corporate to Entrepreneur

New and grow go together, with uncertainty typically right in between them. When I chose to do something new like leave the corporate world and start my own consulting business, I knew I would grow because of it. Coming with this was a massive amount of uncertainty. Who would be my clients? How would I generate revenue for an income? Would I be successful or fall prey and add to the statistics that 70-80% of changes fail? Being able to live with some uncertainty is an essential skill, so

I did. Did I enjoy it, not at all! Interestingly though, you do become accustomed to it.

One of the important factors in learning to become better with uncertainty, was surrounding myself with people who were in the same situation, or who had been looking at the sunrise for red skies. Speaking with these mentors, listening to their reassurances, and stories of how they had been through it as well, helped me build confidence. Their wisdom allowed me to lessen the noise of uncertainty.

Humility and Ego

"Wear your ego like a loose-fitting garment."

Buddha

Check your ego at the door. We have heard this a thousand times entering an office meeting or a sports game/event where we will discuss what did not go as planned. You may have also heard this before participating in a brainstorming session of some kind.

We can't control most things in life. You can't control what other people will think or how much someone else has or doesn't have. In fact, the ego loves to try to control these uncontrollable things – don't waste your time. The good news is that you can control things like your effort and how much time you commit to a goal – focus your power on those!

The quickest way to stop the ego from telling you that you can't do something, is to get started and prove it wrong. Just sitting around and thinking is the perfect environment for the ego to rear its head. On the flip side, getting started and taking action makes it incredibly difficult for the ego to chime in. We love to get caught up in our story and how it may pan out. The problem is, it never turns out that way we imagine – which causes frustration. It's okay to have end goals in mind, but the journey on getting there may look very different than how you imagine it. By focusing on the present moment, and not your story, you'll be more primed to reach your goals.

This is one of the hardest things to do, I know. But the ego thrives on looking at what other people have and telling you what you don't have, making you feel inferior. One of the largest issues with comparing ourselves to other people is that we tend to compare only one aspect of someone's life to our entire life. We look at our rich friend and are jealous of what he has, but we don't spend the time thinking about his problems – trust me, he has them.

So, instead of spending your time and energy focused on others, put the effort into yourself. If you want to compare yourself to anyone, make that person your previous self – so you can learn and grow. Once you are able to identify your true purpose in life, the ego starts to fade away into the background. That's because you have a north star you are focusing on now and you know that hurdles will always pop-up on your way there. You don't let them get you down and you certainly don't care what other people think about your path to fulfill your purpose. Live your purpose, eliminate your ego.

"Your ego is not your amigo."

Unknown

Related Story: Get Humbled

On one occasion, a coach turned sparring partner, caught me with a deadly body blow. I knew this hit was far heavier than the 50% imposed by the coach. In fact, I was self-diagnosed with at least one bruised rib. Not able to take a deep breath, and then overcompensating to protect this tender area, I felt I was going to be in trouble when the time came to compete. Honestly, there was one other time I was very humbled. This was a time I was humbled to the point of taking a knee. No pride in the world could keep me going when I sparred with a 30-year-old club boxer and took several hits to the head that left me dizzy and with slightly blurred vision. It happened so incredibly fast. I had learned, through our sparring, that my reach and quickness were my largest assets, followed by my conditioning. I also learned that what coach

Virgil warned was apparently true. He said that the club boxers will spar at the speed and level you bring. Be aware that they will return as good as you give, and more.

Using my speed and reach, I tagged this younger (younger by a couple decades, not just years) , more experienced boxer, right in the face with a solid jab, snapping his head back. I had not fully pulled my arm back from this *proud as punch* punch, when he unleashed on me. Blocking his first counter only opened me up to a hook cross combination that really stunned me. I came back, but he landed another. It was at this time that no amount of stubbornness or pride could have had me continue.

Seeing the determination in his eyes, and not wanting a concussion, I took a knee. Right there, in the gym with all my teammates around me. My fear was visible to all them, the other fighters, and coaches. I was humbled. Was I afraid? You bet. So, I acknowledged my fear, used common sense, took a breather, and found another way to continue. The better way was to spar at a level I could also defend against. I learned it was wise to acknowledge my competitor's strengths, play within my limitations, all the while eating a little humble pie.

Exercise: Identify Your Strengths and Weaknesses

To help understand the characteristics you have strength in, and the ones you want to develop, take the following assessment. This will help you prioritize which ones you need to focus on and give you an honest assessment to share with potential mentors and coaches.

Rate yourself from 1 to 5, 1 being weakest and 5 being strongest. The outcome of this assessment lies completely in your hands, so being honest with yourself will harness real and useful results.

Characteristic	Weak				Strong
	1	2	3	4	5
Adaptability					
Commitment					
Passion					
Lifelong Learning					
Fearless					
Focus					
Faith					
Embracing Uncertainty					
Ego (1 = high ego, 5 = low ego)					

These results will be used later in two means:

1. To determine key areas to focus working on when establishing an action plan
2. To share with potential mentors and coaches

Chapter Five

WHEN? CHOOSING YOUR CORRECT TIMING

"Do not wait. The time will never be 'just right'. Start where you stand, and work with whatever tools you may have at your command, and better tools will be found as you go along."

George Herbert

If you haven't reinvented yourself yet, but you know you want to, perhaps even have to, what is stopping you? What happens is we get busy. We get caught up in other things. We start to make excuses about the fact that it's not the right time, and make excuses saying we don't have the right amount of revenue or resources. Maybe we're just kidding ourselves and we're just downright scared, so we put it off and don't do anything. Another day, another week another month, and another year goes by and we don't execute anything meaningful. We know that deep down inside, we want change, and we need change. What are we waiting for?

In boxing, I learned that timing was critical. Timing beat speed and power. Just as timing in boxing is critical, so it is in reinventing yourself. When is the best time to reinvent yourself? Is there ever truly a 'right' time?

Similar to change, there are two scenarios here that may potentially impact you. The first being that the need to reinvent yourself has or is being forced upon you. Perhaps from an outside influence or source. In this case, the timing may be set for you, and it might be immediate! Your timing to move through the stages of change will be greatly accelerated. You will need to make decisions more quickly. Do not be afraid to make a decision.

Often, we don't choose the timing for change. It chooses us. The second scenario is when you've come to the conclusion you are ready to make a change. This is a large, monumental change that requires you to reinvent yourself! Now, you may think that in some ways this type of change with its induced timing is easier than scenario one. I caution you! Having a timeline set for you, makes you 100% reactive, while having a timeline in need of being created by yourself, is 100% dependent upon your proactivity. The latter takes many of the characteristics we discussed previously to make happen.

Related Story – Second Career Comeback

Laura Arci shares that when she decided to reinvent herself and have a second career comeback there was no perfect timing. As a matter of fact it was one of the most challenging decisions and life changing experiences for her as she explains: I feel blessed to have had many years being able to love and support my family. It was a tremendous honor to have worked diligently at being a loving mother. My focus is to express that where there's a will there's a way. If you put your mind to something and you plan out the steps to achieving your goals do not lose sight of what your end result will be and your why. I wanted to become a licensed realtor because I needed to be able to provide for my family should some major changes occur to my family life as I knew it. I needed to get uncomfortable to regain comfort. I was far from achieving that goal of comfort, but I felt confident that I would get there if I persevered. I was desperate to regain my independence in order to survive in a world that is not always kind to women going through tough times. It is true that

you know who your real friends are when they stay with you to show support through the good and the bad times.

I enjoyed being a stay at home mom and all the joys associated with motherhood. Accompanying my three children to all their activities, working to keep the home in tip top shape, preparing and serving healthy gourmet meals and wonderful lunches for them to take to school, often times dropping off hot lunches for them or picking my kids up to join me for lunch at home, working in our real estate business behind the scenes by managing the day to day operations and administration. I kept the home clean and also managed to find time to do the outdoor landscaping. My goal when I retired early from my first career at IBM was to be like Martha Stewart, a famous American retail businesswoman, writer, television celebrity, author of healthy living and cookbooks. She was my hero. My goal was to manage all the pillars in my life successfully and to strive to lead an exceptional life. I thought I would have a lot of personal free time to pursue my passions however, my extensive knowledge and training in marketing and sales was sought after by many to help them build their business and brands.

After twenty years of marriage, there came a time in my life when I knew I needed to make some drastic changes that would alter the lives of everyone in my family. Change is not a simple or easy transition. Sometimes we are aware that we need to make changes, but the steps required are very painful and the lives being impacted are significant.

For years, I tackled issues and challenges, until it came to a point where I came to the realization that my life as I knew would forever be changed by the course of events that were underway. I decided that I needed to prepare myself as much as possible. The odds were stacked against me, as I had no parents and not many relatives in Canada. Most often, when people are experiencing major issues, they stay quiet and keep to themselves. That is what I did as well. I continued to manage all the tasks I always did, tried to maintain a positive attitude in front of my kids which was extremely difficult and decided to go back to school. I decided I would plan for a second career comeback. I found the words

SECOND CAREER COMEBACK in a magazine and posted them on a board with some high-profile images of very successful women.

"The time is always right to do what is right."

Martin Luther King Jr.

The bottom line with timing is that there will never be an ideal time. A time when everything aligns perfectly for you to start your journey, is whichever time you've chosen. There is a quote I use when working with emerging leaders, "Leaders don't always make the right decisions, but they make their decisions right!" Make a decision that the timing is the correct timing and go for it!

"The way to get started is to quit talking and begin doing."

Walt Disney

My kids Poppa fought Parkinson's disease for many years. When his body finally succumbed to disease- related symptoms, he was the first close family member to pass away in my kids' lives. This was a difficult time emotionally, as you would expect, for us all. There was an opportunity here to discuss with my kids the importance of living our lives to the fullest while we can. Then, as I do now, I encourage them to pursue and live out all of their dreams in life, regardless of what they are and how much they may seem out of reach. I had my kids give some thought to their own mortality. That one day we all will be on our death bed. I shared with them that we all have choices in the direction our lives take. To pursue what we want to achieve, and to fulfill our goals and dreams, we have to start now! So, I say to you what I say to them, do not ever be on your death bed saying *I wish I would have*...because you can, right now! One thing I will assure you, is that you will look back on your journey, and wish you'd started it sooner. All the people I've talked to, myself included, have this same sentiment.

"The trouble is you think you have time." Buddha

Chapter Six

BARRIERS! OVERCOMING THE CHALLENGES AHEAD

"Don't limit your challenges. Challenge your limits."

You know that your journey may not be a straight line. This means you will be met with opposition, challenges, obstacles, and barriers on the way to your goal. Let's say your goal is to get healthier. This might mean exercising more, eating better, or getting enough sleep. Even though we know these are good for us, the barriers of time, money, laziness, or life get in the way. Trying to eat better? Plan your meals so that you have healthy food options wherever you are. Too tired to go to the gym after work? Sleep in your gym clothes and wake up 30 minutes earlier to go for a walk. Too tired? Don't worry, exercise will help you get better sleep.

During our journey, we will encounter one, many, or all of these potential barriers. Barriers including fear, financial challenges, timing issues, physical, emotional, and mental battles. Use these methods mentioned in this chapter to help you navigate through the difficult seas. Understand the stories shared so you realize you are not alone in having challenges. Overcome, adapt, embrace, and harness each barrier and allow it to make you better, stronger, and more knowledgeable when heading towards your desired goals.

The first step in addressing potential barriers is to identify them. Some potential barriers could include your weaknesses and threats from your SWOT or strengths, weaknesses, opportunities, and threats. At the end of this chapter, you will find a worksheet. In this worksheet, you'll be asked to fill in as many of your potential barriers, prioritized in order of most significant to least, that you can come up with. We will focus on the top five and create actions to minimize and eliminate them. These actions can be included in your 90 day planning.

In this chapter, we will review some common barriers people face when changing and reinventing themselves. Choose the ones that relate most to you and be prepared for them.

"It always seems impossible, until it's done."

Nelson Mandela

Fear

Everyone is afraid of something. Heights, spiders, small spaces, heartbreak, change. Fear is natural in all humans. Fear can be both healthy and unhealthy. Our brain creates fear to keep us safe. And it is an important element that stops us from doing stupid things. But what is it about fear that paralyzes us from doing the things we either know we need to, or want to? Our goal here is to have fear work to our advantage. The first step in having fear working for us, not against us, is to identify which type of fear you are experiencing. There are different fears to be aware of. We will investigate the common kinds of fears in an effort to help you identify your fears before we begin to address them.

"Through every generation of the human race, there has been a constant war, a war with fear. Those who have the courage to conquer it are made free, and those who are conquered by it, are made to suffer until they have the courage to defeat it, or death takes them."

Alexander the Great

Related Story: Facing My Fears

One day, when I was young, my Dad arrived home from work and said there was a box in the back of the truck. Dad was notorious for showing up with items, gifts etc. That particular day, Dad had brought home a box of boxing items. It included 2 pairs of boxing gloves for my older brother Larry and me. The box smelled musty and of sweat. The gloves were old school, with laces for securing them. Was this Dad's way of teaching us to fight? Perhaps to protect ourselves? This was an opportunity to face one of my fears early on in life. As an adult, I have identified a couple of fears that challenged me in overcoming them.

My first fear was the fear of missing out. We've discussed how we often need to give something up to pursue something else. In my situation, I realized I would need to give up playing hockey. In doing so, I was also giving up my weekly connection with my friends. So, in fact, I was afraid I would miss out. Miss out on all the good times, the stories of them, their families, hearing about their businesses, and more. This concerned me. When I analyzed the fear, I looked at alternatives that would allow me to lessen the fear. I decided I would dedicate myself to visiting the guys after Wednesday hockey nights. This decision lessened my fear and turned out to work out well to keep me connected with my friends.

My second fear was revealed to me later on in my journey. The fear of not being good enough. I am a very confident person. I'm young at heart, vibrant, and full of energy. Rarely does my age ever come to mind as a potential barrier to achieving any and everything I want. I often think of my age as a tremendous advantage, having more years of knowledge, experience, and learned skills over the years. However, during one training, specifically during sparring with boxing club veterans, fear began to creep into my mind. On a couple of occasions, I got filled-in by more experienced, and younger boxers. I was using everything I had learned, and still couldn't stop the onslaught of punches that penetrated upon me. How was I going to be against my opponent on fight night? In

front of many people that are very important to me? Yes we discussed and always said we were all winners for entering this event regardless of the outcome in the ring, but deep down none of the 10 fighters was going to be satisfied if they lost their bout.

What types of fears do you face today? Here are four of the most common ones:

Fear of being wrong People harboring this fear are extremely focused on rules, ethics, standards, and *right vs. wrong*. They are deeply afraid of making a choice that will later prove to be *objectively* wrong. These perfectionists put a lot of pressure on themselves and those around them.

Fear of not being good enough The fear of failing.

> *"Do not be afraid of failure, be afraid of regret."*

Those with this fear tend to be insecure, intensely focused on their image, and desperate to prove their worth. This may come at a cost to their authenticity, not to mention their capacity for joy. What's more, because their core motivations relate to how they are seen by others, they tend to fudge facts.

Fear of missing out The first time I heard the phrase FOMO or fear of missing out was from a teenage family friend. I had to Google this since I had no clue as to what it meant. From their perspective, it was a fear of missing out on what their friends would be doing, saying, or who else they were hanging out with. In our case, this FOMO drives many people to constantly seek new opportunities and experiences. The problem? It can dilute our attention and muddy our decisions.

Fear of being victimized or taken advantage of In this fear, we are afraid of being seen as weak. We feel the need to win every battle and can be defensive and controlling. Perhaps, in the past, we have been

victimized and do not want to place ourselves in this precarious position again.

4 Steps to Harnessing Fear

As mentioned, we want these identified fears to work *for* you. Harnessing fear is much different than overcoming fear. Fear is an energy, and we need to learn to harness and direct it to where it will benefit us most, and in positive ways. Fear can create adrenaline, which when used correctly, can be very powerful. It can also be very destructive.

Step 1: Acknowledge the fear.

As a high achiever, I always strive for more. I seek more challenges, and more successes. But at times, it can come with some fears. Always pushing oneself to do more, to be bigger, to be faster, and to be better, is not an easy thing to do. After all, I always did a great job of covering up my fears. I have been told that, on the surface, I am very polished and put together. When I signed up for the fight to end cancer, I was mentally ready for the physical challenges, the time commitment, and the fundraising efforts. What I couldn't have anticipated was the anxiety and fear of getting in the ring and sparring, and eventually having an open fight with another person. At first, I thought I would pull on my experiences from hockey, where on occasion, I had fought opponents. On only a few rare occasions did I ever engage in a street type fight. As mentioned earlier, in my teenage years, I used to box in the yard with my brother. There was a side of me that felt my controlled aggression would be my secret weapon if I needed to dig deep. As we began sparring, I took punches to my body and head. On occasion, they stunned me. These did not hurt me, but they could blur my vision, bloody my nose, and bruise a rib. This hurt for days and in the case of the ribs, a couple of weeks thereafter. In these moments, I was experiencing fear. In this 'acknowledging of fear' phase, we need to understand and accept that we do have fears.

Step 2: Interrogate the fear to better understand it.

We need to critically assess our identified fears and its impact on us, paralyzing or otherwise. After learning I had some fear, specifically two kinds, I dug deep and questioned where these fears stemmed from. Let's spent time considering what it would mean if a failure became reality. Take a fear and think of the worst possible outcome. Here's my example:

a. Fear of being taken advantage of – worst possible outcome = being beat up in the ring in front of all my family and friends and losing the fight

b. Fear of not being good enough – worst possible outcome = not raising enough awareness and funds for a cause

My instinct tells me that failure would leave me with no win, mounds of embarrassment, and eight months of time wasted on zero results. I had to acknowledge these instincts, but then move past them. Other people made mistakes and they moved on. Why couldn't I? No one actually walked around with an 'L' on their forehead. What was I so afraid of? I would be a winner for stepping in the ring and raising whatever funds and awareness I could for a great cause. My true objectives would be met, even if my worst fears came true. I also began to see how my unfounded fears were worsening my behavior, and by giving them energy, there would be less for me to make use of in the right areas.

Step 3: Choose a different course of action.

This is about deciding what to do next to address these fears. Ask yourself: What can I do to reduce the chances/odds of the worst possible outcomes coming true?

For me the solution was to:

a. Train smartly, create a fight strategy, and spar opponents similar to the opponent I would be fighting

b. Focus on awareness, which was just as important as the funds. Early detection could save more lives in a pre-emptive means, rather than a post-care one.

Exercise: Addressing Your Fears

Let's assist you in harnessing your fears. Name below any fears you have identified and interrogate them, then chose a potential different course of action.

Fear	Interrogation	Different Course of Action

Step 4: Execute Actions

We must make a conscious choice to work hard on aligning these actions with our passions to reduce the risk of the worst-case scenario. For example, I spoke to my coaches and shared my concerns. I then prioritized sparring with partners who resembled my opponent in size but were more experienced fighters. I learned their techniques to counter my strategies and skills, forcing myself to adapt and prepare as thoroughly as possible. This reduced my anxiety and fear, convincing myself I was not only prepared, but had done everything possible to put myself in a position to be victorious. This in turn build my confidence. For building awareness, I focused on my outreach and the benefits and importance of early detection which could save lives.

When we are controlled by fear—or when we pretend it's not there—fear can and will cripple us until we become powerless. None of us will ever be free from fear, and it's unrealistic to expect that we can always put our fears in their place. But even when the stakes of admitting your fears feels high, you are always more effective when you acknowledge fear, interrogate fear, and investigate options to lesson the fear. Fear is legitimate. You will want to do the hard work to right-size your fears. When we take these actions regarding our fears, they will greatly diminish in size.

When starting out on a journey of change by reinventing ourselves, seldom will we think about the downsides of this journey, at least not in the beginning. Our initial thoughts are fuelled by the enthusiasm of new adventure and this new journey we are going on. Even those with a well thought out plan can have it disrupted.

"Everyone has a plan, until they punched in the face."

Mike Tyson

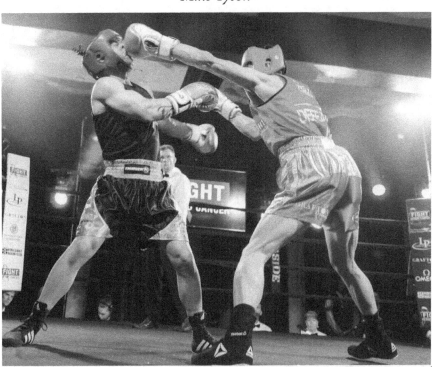

F.E.A.R. has two meanings:

Forget Everything And Run

OR

Face Everything And Rise

Which will it be for you?

CRAP: Criticism, Rejection, Assholes, Pressure

Criticism

We often hear people say "I am putting up with a lot of crap right now." Just what exactly is this 'crap' they speak of? CRAP, stands for the following: Criticism, Rejection, Assholes and Pressure.

Criticism

Talk about a gift for people who believe it is better to give than to receive! People will not always understand your decisions and actions to reinvent yourself. They also may not have had the strength, characteristics, and support to accomplish their own reinventions, and because of this will criticize your efforts, your direction, your reinvention. Criticism is ramped up and abundant in today's society. A small amount of knowledge, usually gained from the internet and social media, immediately makes people believe they know better than you.

One observation I have from the field and from working with dozens of leaders in change, is if you are being innovative, people will ask what your evidence is. If you are drawing upon an evidence-based point of view, people will challenge whether your evidence rings true and they may challenge you on its validity. We need data to defend criticism from uninformed outsiders, but also be open to criticizing ourselves in the spirit of improvement. Criticism is normal. A bunch of non-

independent thinkers do not advance ideas or improvement. The types of criticism that I reject are unsolicited ones based upon uninformed opinions and vague criticism that I don't know how to interpret or put into actionable improvement. We all need 'the devil in the room' to ensure we haven't missed anything in our planning, but we also need the correct filters to ensure we don't let naysayers persuade us against our goals.

> *"It is not the critic who counts; not the man who points out how the strong man stumbles, or where the doer of deeds could have done them better. The credit belongs to the man who is actually in the arena, whose face is marred by dust and sweat and blood; who strives valiantly; who errs, who comes short again and again, because there is no effort without error and shortcoming; but who does actually strive to do the deeds; who knows great enthusiasms, the great devotions; who spends himself in a worthy cause; who at the best knows in the end the triumph of high achievement, and who at the worst, if he fails, at least fails while daring greatly, so that his place shall never be with those cold and timid souls who neither know victory nor defeat."*
>
> Theodore Roosevelt

Rejection

Often seen as the flipside of acceptance, one of the toughest lessons for people to learn and grasp is to not take rejection personally. Admittedly, I have confused rejection with ostracism. Rejection happens both passively and actively. The former keeps me up at night and the latter sometimes raises my "fight or flight" response. I have come to expect that people will reject new ideas or even proven ideas if it collides with their worldview. So, to address the possibility of rejection, I have learned more and more about how the *introduction* of an idea–new or old–is sometimes more important than the idea itself. This is key if we

want people to have openness to the experience of a new idea and have acceptance of it. Sometimes this means being a straight shooter, rather provocative, with some charisma, and perhaps even some bravado. Other times it can mean being patient, soft-spoken, and almost giving an apologetic introduction of an idea. Other times still, it is a big room full of people where there are more likely to be some kindred spirits, whereas other times it is a small kitchen table trying to pull together a small coalition of like-minded people.

Situational awareness, knowing your audience, and emotional intelligence are so key for creating an environment where rejection is less likely. Be sure to address individuals differently when sharing and looking for support from others. Should you encounter rejection, which you most certainly will, be a good listener and resist taking offence and feeling like you need to argue with the rejector. It isn't that you don't care about their opinion. Either way, it is not changing your resolve in advancing the reinvention of yourself. There are many opinions out there, and they all will not align with yours, and this is not only alright, it is exactly why you get to do what you want to do, and others as they want.

Assholes

Oh yes, they are out there! Perhaps, closer to you than you think, and perhaps you've even used the term to describe them. They come in many different forms. The biggest assholes I have had to deal with are "professional" controversialists. These people who create data or misinterpret data to *prove* their point, people who constantly interject without listening, people who have opinions on things they have no knowledge of, and people who spend most of their time putting others down. Then there are *the jealous assholes*. Those who deep down admire what you are doing, but don't have the strength to do it themselves, so they put you down and place doubt in your mind. For them, I suggest you buy and give them their own copy of this book. For all assholes, save your energy for your goal, and don't engage in their pessimism.

"You will never reach your destination if you stop and throw stones at every dog that barks."

Winston S. Churchill

Pressure

Regardless of whether we have our path pushed on us or decided to take the journey ourselves, you will feel pressure. And self-pressure can be more cumbersome than any kind. Pressure can start external, but it is when we internalize this that pressure can consume us, burn us out, and diminish our desire to make positive change happen. Positive tension is a good thing in most instances, so holding things in balance is key to success. View this pressure as a good thing. Use it to motivate you, and to hold yourself accountable.

CRAP happens. If you are prepared for it, you can ride the waves and even use it to your advantage. If you let it consume you, you will find yourself buried, unhappy, and less likely to want to affect change.

Some tips:

- Spend time thinking about how you are likely going to be criticized in advance of launching your new approach.

- Be open to feedback – even critical feedback – when it is provided in the spirit of improvement.

- Think of the best ways to get your ideas across – new or old – depending on the audience at hand.

- Practice a variety of approaches of generating support for the same subject matter.

- Don't respond to assholes…their quest is to tear down without a solution focus. Investing your time with them only legitimizes their assertions.

- Determine when and how you will respond to external pressures so that you can still exercise appropriate self care.

Related Story – Second Career Comeback

Laura elaborates on some of the challenges she overcame during her reinvention of herself; In actual fact, it was not easy for me to get my real estate license due to the stressful times my family and I were experiencing and the unknown of a second career comeback. I had always been part of a global corporation and recognized as a visionary leader well compensated for my contributions to the business. What I was facing as I reinvented myself was a complete change in how I conducted business. I was an entrepreneur responsible for starting my business as a solo realtor. The fact that I shared the same last name did not help as clients wishing to do business with a realtor with the same last name as me would choose the more experienced realtor and given that I was new in the business I had a lot to prove. Furthermore, you can have whatever name associated to you, but it is you as an individual that must demonstrate competence, commitment to deliver top results and meet or exceed client expectations. My business was based on professional likeability and trust.

There were many that did not believe in me or thought that I would fail after many years of being outside of the workforce. Never give up on your dreams or your goals. I never thought after early retirement from IBM that I would have a second career comeback, but in life you are on a journey that you do not always control the path, but you can fight hard to get the outcome you desire. Sometimes you are put on a path and there could be destruction along the way. My viewpoint is you need to focus to get yourself out of the trouble. Do what it takes to survive. Swim do not sink. Heal do not stay in grief mode. Believe in yourself, do not doubt. Stay committed, do not get distracted by the voices you hear ridiculing you or making assumptive false statements. I was never a quitter and I will never be someone who gives up. I may have been in terrible pain and agony, but my three children were counting on me. My failure would result in me being a very poor role model so giving

up would never be an option for me. I recognized that I needed to get myself into a very positive state of mind. I went back to basics. I reviewed my notes from years of research, planning and proven techniques that I implemented throughout my life that enabled me to be the best version of me. I wrote a set of positive affirmations and posted them all over my home so that I could recite them every day. I updated my vision board and I looked at the words I had originally posted 'Second Career Comeback.' I reflected that what seems impossible is possible. I added many goals, images and photos of my dream home, the car I always wanted, clothes, how I wanted to feel, the healthy lifestyle I craved to adopt and family aspirations. I created a daily routine checklist as simple as it was, but it helped me to stay focused and served as a gentle reminder every day of what I needed to accomplish. I share this and more in my book Ignite Your Fire.

"Where there is a will there is a way!" Laura Arci

Financial

How much money and wealth are enough for you to be comfortable to take your journey? The real question is, enough for what? Enough to retire? Enough to live a life of luxury? It's true we have to live within our financial means, however, our finances should not always determine our goals and direction. We need to find a way to financially support ourselves while we achieve the reinvention of ourselves. Do your best to find the means, resources to fund and carry out your reinvention. Take the time to determine the finances necessary before you begin your journey. But do not let financial means detour you from your desired state. Remember, don't say "I cannot afford to do this right now", think

" I cannot afford not to do this right now".

Physical and Emotional Barriers

Strengthening our bodies as well as our minds should be an ongoing focus for us. For without being strong of body and mind, we can't

accomplish everything that we want to. Even if our goal is to be the best that we can be for others, we need to be in the best shape possible to help them. There is a reason that, when you're on a flight and they're giving you pre-flight safety instructions, they recommend you should put your own oxygen mask on first, before helping others. You have to be in the best shape you can be to help others and even yourself during this journey of reinventing yourself. Helping others first is the key to happiness and success, however you define it.

If your reinvention involves something physical, as one of mine did when turning myself into a fighter, you will follow the steps required by your trainers, coaches, and mentors, just as I did. Regardless of your reinvention, your mental strength and clarity will be vital. Mindfulness is becoming more mainstream, and is a word more people are accepting to, than meditating. Being clear and strong of mind is essential to our success. Designate some time for mindfulness. In Wikipedia, mindfulness is described as "the psychological process of purposely bringing one's attention to experiences occurring in the present moment without judgment, which one can develop through the practice of meditation and through other training. Mindfulness is derived from sati, a significant element of Buddhist traditions, and based on Zen, Vipassanā, and Tibetan meditation techniques." There are many applications for developing mindfulness in order to discover its benefits.

Distractions

One of the worst things to escalate in recent years, are distractions. Yes, there have always been distractions, but never in history have so many been so readily available at our fingertips, literally! If we are going to be successful in reinventing ourselves, we are going to have to avoid, reduce, and eliminate distractions. Obviously, the cell phone and social media are huge distractions. But I want to go beyond this. I want to address the extreme multitasking we do on a regular basis. We believe we can pull it off, do many things at once, and have the results turn out just as great. Well, we cannot. Studies have proved this.

Exercise – Multitasking

Let's do a simple exercise to prove this point. I would like you to count from 0 to 10 and be conscious of the amount of time it takes you to do so. Go ahead and start. Now, I'd like you to go through the letters of the alphabet, starting with A until you come to J. Take a moment to think about how long those took you to perform. I'm guessing, probably about 10 to 12 seconds each. Now, what I'd like you to do is combine the two tasks and combine the letter with the corresponding number, until you reach 10. So, you will begin with A1, B2, etc. Did the last exercise, where you combine the two, take longer than the first? Absolutely! It did because our brain has to multitask. We can't truly do any two things in parallel, as well as we can do them in singular.

If we are to reduce and possibly even eliminate distractions, it means that we have to prioritise what's important to us in this reinvention. To change yourself should be a top priority, since we can only do a few things properly at a time. As a priority, eliminate things that can wait. Focus your time and energy on the top priorities only.

Related Story – Prioritization by Warren Buffett

Warren Buffett, a self-made multi-billionaire, shared an exercise he created on prioritization with his personal pilot. Mr. Buffett asked his pilot if flying was what he would like to do the rest of his career. The pilot answered no. Warren Buffett then took him through a three-step process. He first asked him to write down a list of 25 goals, whether career-oriented or personal. Secondly, he asked him to do some soul-searching and choose the top five goals with the highest priority. Thirdly, he asked him to take a good hard look at the 20 goals he didn't circle. He told the pilot to avoid these at all cost, since they would distract him. Focusing on the goals with low priority would only take up his time, energy, and focus away from achieving the top five. The point of this exercise is twofold. 1) Determine what your top priorities 2) Determine what your low priorities are. Since we have a limited amount of time, energy, and resources to put towards achieving our main goals, we need

to focus 100% of ourselves on the prioritized goals if we want to reinvent ourselves.

Exercise: Predicting and Addressing Potential Barriers

"Be prepared, not scared."

Go through the Warren Buffett exercise to determine your top five priorities. Then, list some potential distractions to achieving each priority. Now, consider each of these distractions and create potential solutions to overcome them should they arrive. This will give you a starting point so you are not caught off guard by the potential pending distractions to achieving your goals. Build this out further as you encounter them.

Priority	Priority	Distraction/Solution
1		
2		
3		
4		
5		

Getting Tire

"I have self-doubt. I have insecurity. I have a fear of failure. I have nights when I show up at the arena and my back hurts, my feet hurt, my knees hurt. I don't have it. I just want to chill. We all have self-doubt. You don't deny it, but you also don't capitulate to it. You embrace it."

Kobe Bryant

Related Story – Rick's Break

There is no shame in taking a break. Everyone needs to rest at times. During my training period, I jetted off for a vacation. It was a couple of months ahead of the fight and the timing was perfect as my body and spirit were being a little run down from the intense and non-stop training. We know that our body only gets stronger when we physically push it. But we need to remember that it only strengthens during rest and recovery. If we continually push and tire ourselves, mentally and physically, we will never grow to our potential, and we run the risk of injury. Injury occurs when the mind and body cannot handle the workload we are giving it. Avoiding injury and other detrimental setbacks from overwork and stress will be imperative to reaching your goals and overcoming barriers. Ensure you build in rest periods each day and week to stay at the top of your game. Set milestones and celebrate them with a night out, a weekend away, or even an entire week away from everything you've been focused on. You have earned it, and you will be amazed at how refreshed, renewed, and ready to continue your journey you will feel. While I was away for a week, I did some alternative training, more active recovery than anything. This included swimming, yoga, and meditating. It gave my body and spirit time to heal, and strengthen itself in other ways for what was ahead. For driven and determined people, this can seem like a waste of time. For the intelligent and disciplined person, this is time well spent. Remember, "rest if necessary, don't quit".

> *"Life is a treadmill. If you stop moving,*
> *you'll actually be going backwards."*

> *Rick Denley*

Chapter Seven

TOOLS - USING THE CORRECT WRENCH

"Keep away from people who try to belittle your ambitions. Small people always do that, but the really great make you feel that you, too, can become great."

Mark Twain

During my journeys and reinventions, I made use of tools I had learned to use in business and in my personal life. Tools can be very helpful to not only accelerate the time to complete a project or journey, but also to help ensure we take actions in an efficient, effective manner. When I have had the opportunity to speak in front of technical audiences, I start by joking that I am a *recovering engineer*, hoping to break the ice with a laugh. What I explain to them, is that I no longer qualify as an engineer in the practicing field but was educated in the initial stage of my career. One of the tools and techniques I will share with you is *Reverse Engineering*. This strategy has you creating the end result in your mind and then visualizing what the end goal will be. Take the time to clearly define the end result you desire. With this in mind, you can now break down the actions, milestones, timelines, and achievements needed to get you to your end goal.

Now that you know what the end goal looks like, it is time to consider breaking this BEHAG (big, hairy, audacious goal) into smaller chunks and timelines. It is here we can introduce timelines to these smaller goals and begin to put some commitments down on paper. Just as essential is setting clear timelines for completion, which will be able to help you achieve these small and BEHAGs, measure when they are completed, and finish the specific actions needed to achieve them.

A useful tool for you is a SWOT (strength, weaknesses, opportunities, and threats) analysis. In devising one, you should consider not only your current strengths and weaknesses, but also your most distinctive qualities and enduring characteristics. Note your traits, habits, and competencies that have held steady over time. These combined will enable you to clarify both what is going well and what might need to change relative to your long-term vision. You will use this analysis to help you choose your next steps and actions and continue your journey filling in the 90-day planner.

Personal SWOT Analysis
(use these prompts to help you)

	Strengths	Weaknesses
Internal	What am I good at? Skills Talents Personality Achievements People that can help you	What's not so hot? What could you improve? Mental blocks Missing skills Personality
	Opportunities	**Threats**
External	With those strengths, what could I do that I'm not doing already? e.g Future studies Further/Higher Education Career	But what could stop me? e.g Obstacles Accidents Peer pressure? Drugs?

Keep the external areas in mind when you begin the process of choosing a mentor or coach. This individual, and others in your circle, should be able to assist you in your areas of weaknesses, help minimize your threats, and capture your opportunities. What do you need to retool in yourself? Is there anything you need to condition your mind to do?

Related Story: Bloodied Knuckles

I would imagine you're expecting this story to be related to my fight training. You are wrong. I never bloodied my knuckles during training, sparring, or even in a fight. This is a little difficult to do when wearing wraps and padded 16oz boxing gloves at all times. The correct tools can make all the difference and there are many different types of tools we can make use of.

From an early age, I enjoyed working and fixing things. Mainly because I was curious. I would take them apart and have to put them back together. I focused this *tinkering* on bicycles when I was young and that turned into motorcycles and then cars. I remember early on, organizing what I called *Dad's shed*, in our backyard in Etobicoke. Dad's old workbench had some tools and I got my small red toolbox, given to me one Christmas by 'Santa', and set-up shop. I placed all the tools we had in a nice and neat order on the peg board above the work bench. When we didn't have the correct-sized wrench, I would go to the trusty Vice Grips. This all-in-one clamping wrench would fit any nut and bit into it, allowing it to be turned. The problem was, it left teeth marks in the nut, and on occasion would slip off usually while under great torque. This would send your knuckles scrapping off harsh metal nearby, thus rendering your knuckles with a little less skin and a lot of blood to show for it. Not knowing the correct tool to use, and how to use it effectively, can leave you, your journey, and those around you, a little worse for wear. Knowing the correct tool for the correct job and how to use it, can make an immense difference to not only a more enjoyable experience, but also help ensure the results you want to occur.

Support

Reach Your Goal Faster

The research is clear about how we grow most successfully. It is a combination of on-the-job, social, and formal learning, also known as the 70-20-10 model. This model was created in the 1980s by three researchers and authors working with the Center for Creative Leadership, a non-profit educational institution in Greensboro, N.C. The three founders, Morgan McCall, Michael M. Lombardo, and Robert A. Eichinger were researching the key developmental experiences of successful managers. Their research-derived mantra says that roughly 70% of your growth will come from the related experiences you have, 20% will come from your interactions with others, and 10% will come from formal education and training.

Think of growth as a cycle—successfully perform, get feedback, and perform again even better.

Experiences power that growth cycle, so you'll want to understand which experiences matter most, and gain as many of them as quickly as possible. To begin, you want to be very clear about your starting point and desired destination on your reinventing journey—an obvious item that's often missing during the planning stages.

Exercise: Identifying Available Resources

Two key steps to grow faster are:

1. Determine your from/to

2. Gain the experiences and learn from them

Before taking action, figure out what resources and support are at your disposal. What brilliant minds do you have access to? Who can you consult for advice? What can you read, absorb, and take in that will help you on your path? Let's start with potential mentors and coaches.

Mentors and Coaches

People come into our lives to teach us. Some stay, some move on, some leave. Throughout our lives, we have people that help us learn. They guide us on our journey and help us minimize errors in getting to where it is we are trying to go. From birth, it is our parents. They are there to nourish us, protect us, and show us how to speak, walk, behave, and interact in social settings. As we get older, we are introduced to others that have a skillset unique to the learnings we are seeking to achieve. Teachers in school, music instructors, coaches in sports, bosses in business and careers, and eventually mentors impact us tremendously.

Mentors are unique relationships. These are relationships mutually agreed upon, as opposed to being mandatory like other relationships. A mentor and mentee have an unwritten agreement to help each other learn and grow. It may seem that the mentor is the one always teaching and leading, but they, too, are learning in return. As coach Jen from our boxing training said:

> *"Think of mentors you have had during your lifetime. When reinventing yourself, having a mentor through this transformation can be enormously helpful in ensuring your timely success. Through an approach called 'shared experiences', they guide us towards our goals and many times around the potential pitfalls, having already been there themselves."*

Who will be your mentor through your reinvention of yourself? How do you choose a mentor? Keep these things in mind when choosing a mentor.

You are the average of the closest five people in your inner circle.

Exercise: Identify Your Inner Circle

Who is in your inner circle?

	Who?	**Positivity/Energy They Bring**
1		
2		
3		
4		
5		
6		
7		
8		
9		
10		

Are these the people you want in your life? Are they supportive? Do their values align with yours?

In very simple terms, there are two types of people: ones that take your energy, and ones that bring you energy. Which type are each of these people?

Creating a Mentor Pick Checklist

Create a checklist for yourself from these points. Keep in mind, some attributes can only be judged after the mentoring relationship starts – so maybe, not committing to a long-term and intense schedule of meetings, will be a good starting point.

Is this person:

1. Someone you admire and respect? Find someone who has a good track record and credibility – especially in the area of your final vision result. This person will have achievements that impress you.

2. Someone who has a lot to offer you? Make sure you can articulate what these things are.

3. A person who enjoys challenges and knows how to challenge you and help you focus your thinking?

4. Someone with whom you enjoy meeting with? This person should not be someone who is patronizing towards you.

5. Able to relate to you? Can they relate to people with less skills and experience than them?

6. A person who makes commitments and follows through? Find someone who can give you sufficient time.

7. Someone with a genuine interest in your advancement? Someone who will be interested in you and your end goal, not just advancing themselves.

8. Someone with whom you can be yourself, without putting on a formal façade?

9. A person who has a good network of influencers? Find someone who is able to pick up the phone and connect you with learning opportunities, events, and guidance in areas he/she does not specialize in.

10. Someone not controlling? This person will not be making decisions for you, so avoid someone who continually offers their

own solutions. They should ask useful and interesting questions and engage you in developing your own ideas.

11. Someone who takes a collaborative approach to solutions when nurturing your ideas?

12. A person who has similar standards and values to yours? Choose a mentor who values mistakes for learning purposes, has great interpersonal skills, is a good listener, and is open and honest. This person will give you feedback in a positive, albeit candid manner. Select a mentor who values learning and can challenge high achievers. This way, they can help you experiment in a safe environment.

Exercise: Determining Potential Mentors/Coaches

Mentoring is much more collaborative than most understand it to be. You will get out what you put in. Once you begin a mentor-mentee relationship, ensure you are making the most of your time together with these tips:

1. Be humble. Forget about whatever status or acclaim you've had in the past and assume the role of a novice and learner.

2. Admire. Remember, it's not all about you. Sincerely appreciate what attracts you to your mentor and do so in the right way, time, and place.

3. Be understanding. Seek first to understand their perspective before trying to show them how much you know.

4. Give. Reward and repay your mentor by seeking ways to add value back into their life. Sometimes it comes by maximizing what you do with the mentorship you've been given, and other times, it's something more reciprocal.

5. Produce. Successful people and companies won't continue to give to what doesn't reward them back. Make sure you're adding progressive value to the individual mentor, as well as to the enterprise.

6. Practice the highest standards of professionalism. Although this sounds simple, it is at the core of mentoring and at times, forgotten. You want to establish a commitment of trust and mutual respect.

7. Learn to accept and give feedback. The good news is, you will receive feedback and insight from a knowledgeable and caring individual. Many times, this feedback will confirm that you are on the right track. It will be congratulatory when you have achieved a successful milestone. But sometimes, the feedback will be less than flattering. You need to be receptive to both kinds of feedback, both positive and negative. Learn to accept feedback that's intended to improve your path.

8. Practice good communication. Learning to communicate effectively is a lifelong challenge, particularly for those who materialize ideas into tangible actions that, in turn, will impact a career path. Mentoring relationships thrive on good communication. Remember that your mentor cannot read your mind!

9. Communication tip: Take the time to keep your mentor up-to-date on how things are going or not going for you. Provide feedback on how well a strategy or approach you tried worked or failed. Try and not overinterpret a comment from your mentor, who is probably just as busy as you are. Stick to the facts and make sure you keep in touch!

10. Consider a periodic mentor checkup. Mentoring relationships, like most things in life, can benefit from regular evaluations. As a mentee, you should evaluate whether this relationship is still

helping you or not. The ability to judge whether you need to switch mentors or not, is essential to staying on track.

11. Recognize that your path is your responsibility. Now that you understand your why and how, have set your goals, found the ideal mentor, and launched a relationship, remind yourself that you are still the one who is ultimately responsible for your path.

Exercise: Create a 90-Day Plan

To have a stronger understanding of the areas you need to take action in, let's look at this next exercise together. We will identify actions to take, set measurable goals, tag people who can assist us, and secure firm timelines for completion.

Choose the actions you need to accomplish within the next 90 days. Fill in the categories below, giving special thought to the specific outcomes to be achieved. Once you've completed this chart, start asking for mentoring and coaching from those within your circle and look out for resources which can align with you for support. Earlier, we discussed the importance of communicating our goals to those in our circle—and this is the next step. When you complete an action, be sure to check it off and celebrate! These 90-Day plans are living and breathing documents that should be refreshed, you guessed it, every 90 days.

Action	How will you measure success	Who could help	Next Step

Remember that you—the mentee—own the mentoring relationship. You need to bring your energy, passion, vision, and enthusiasm for the complex and challenging tasks ahead.

Chapter Eight

GRIT - STAYING THE COURSE

"Impossible is just a big word thrown around by small men who find it easier to live in the world they've been given, rather than to explore the power they have to change it. Impossible is not a fact. It is an opinion. Impossible is not a declaration, it is a dare." Muhammad Ali

Angela Duckworth wrote a book, and in it she shares what years of research has determined to be the one underlying factor in people being successful. Grit.

"Grit is about working on something you care about so much, that you're willing to stay loyal to it. It's not about falling in love; it's about staying in love."

Angela Duckworth

A part *of grit* is the ability to withstand, use, and understand pain. We all experience pain—physical pain, mental anguish, loneliness, and heartache. I, like many of you, have experienced all of these types of pain throughout my lifetime. Some of these types of pain are why we have chosen to re-invent ourselves, to make major changes in our lives. We learn that pain is temporary, and that time heals all pain. Our brain

soon forgets the pain our bodies and hearts have been through. This is why after we have our hearts broken, we seek out another relationship, even though we know we may get hurt again. And it's a good thing we forget, because if we didn't, we would be paralyzed.

I mentioned that sparring, during my boxing journey, started off as defence. This remained for several weeks, as I learned to block punches. Well, some of them, not all, since I was still learning this skill. So, I got punched, a lot! In the head, as well as the body. This wasn't fun. I began to learn to control my trigger to hit back. To learn patience. To learn that the pain I was feeling, was temporary.

One of the other sports that also taught me about pain management was cycling. Cycling, you say. But you're a man who has played competitive hockey for years, and cycling taught you pain control?' Absolutely. When you're out there on a long ride or race, there are no breaks, no time outs, and no time to recover. I learned to absorb the pain, learn from it, harness it, and redirect it back out in a controlled fashion. This is also being gritty. Think of a time when it was grit that got you through something.

Related Story: Lost in the Mountains

I recall one summer, vacationing in Mount Tremblant, Quebec, with my family. My kids were in their early teens and my brother and his family made the trip with us. I decided to go for a mountain bike ride on some fairly well-marked trails. The challenging terrain kept my focus, and before I knew it, I was deep into the Laurentian mountains and had been riding for a couple of hours. Taking a few poorly marked trails quickly placed me in no man's land. I was unprepared for such an adventurous ride, and realized I was lost. Checking my cell phone, a far less sophisticated device back in those days, it failed to have a signal and thus, was useless to me. Not only could I not figure out which way to go back to our resort, I had no means to inform the others that I was delayed or ask for help. I tried to judge where the sun was, to gain some direction back the way I came, but that didn't help.

After riding a few more main trails, I came across a French speaking woman riding, as well. Might I say here that I regret not listening more in my high school French class. Between my terrible understanding of the French language, and her non-existent grasp of the English language, she sent me off in who knows what direction. So, there I was. I didn't have a clue as to which direction to go in. My water bottle was empty, I ran out of snacks, and if I had any semblance of energy, it was deceiving. I was somewhere lost in the mountains and I knew I had to keep going. There wasn't any other option.

Finally, I heard some cars in the distance! I rode in their direction and came to a trailhead of a road—a fairly busy road. Looking both left and right, I had no idea which way to go. I recognized my cognitive skills were weakening by the minute, due to a lack of water and food. Looking to my right, the road curved and went uphill. I figured this would be the way back to the mountain by our resort. So, I took that direction, riding on the side of this busy road, with cars occasionally passing, and heading up the hill. After about 20 minutes, I approached a crossroad and signs. Reading the signs to gain my bearings, I slumped over the handlebars in disbelief. In this state of *bonk* as cyclists call it, I had been riding in the wrong direction. I wanted to cry. I had nothing left in me.

According to the sign, I had 12 km to go before I had fresh water, food, and a place to rest. What was I to do? My phone may have worked, but I had no idea where I was. I sat on the side of the road. Gathering my self together, I slid back on the saddle, now shaking at this point, because of exhaustion. I pointed my bike in the direction of the resort, a heavenly place to me now, and pushed on. I made it back. Never more exhausted in my life, I had no feeling of accomplishment upon my return. Not only was I embarrassed in front of my extended family, they showed very little sympathy, as they had been waiting for my return so they could go to the beach.

Staying the Course

Inevitable barriers, challenges, and weaknesses will try to derail your progress. Your 90-day plan, with its specific actions and timelines, and aligned support from others, will help you be successful regardless. You have begun this process and started executing these actions. Although some aspects are coming along nicely, and you feel progress, some of them are not gaining traction the way you had imagined. They are not following the timeline you imposed. This is the two-steps forward, one-step back scenario. And this happens to everyone.

Perhaps you are deciding on a fallback plan to go along with your main plan. A *plan B* if you will. Something that, if this reinvention of yourself weren't to pan out, you'd have a safety net to fall back on. Should this be your current way of thinking? I would like you to give this some serious consideration. Oh, hell, I'll just say it, don't! Don't have a plan B! Don't have a safety net! We cannot accomplish BAHG, while in the back of our minds we have one of these *in case I lose* options. Take away the safety net. Take off the training wheels and go for it! Removing the safety net will ensure that there's no turning back. The ancient Greeks understood this very well. When they'd attack by sea, the first order they'd give after reaching the port, was to burn their boats to ensure no one could turn back, that victory was their only option.

Exercise: A Letter to Yourself

Take time now to write a note to yourself to encourage you not to give up. Remind yourself why you are doing this, how the end result will make you feel, how *this is* where you want to be. That pain and stress are temporary, and your end goal will be with you forever.

Dear (your name), I know things are hard at the moment—the challenges, the emotions, the pressures. But I want you to remember why we started this journey, why we are doing this. We are doing this because _____ _____. I have confidence in us, that we will get through this, and complete this journey. Stay the course! Read

your empowering, motivational quotes, and envision what the end result will look like. Think of the number of people that want to see you fail. Don't give them the satisfaction! Yours truly, (your name)

> "Work hard now and live the rest of your life
> as a champion."
>
> Muhammad Ali

Check-In's

Frequent check-ins will help ensure you're on track. Regular analysis is required to take the pulse of your reinvention. We need to revisit our objectives and goals and ask ourselves *Am I on track with the goal I have committed to?*

Related Story: Mid Journey Check-In

Four months into my six-month boxing training, I started to be aware that the actual event, my first fight ever, was getting close. I took inventory of where I was in my development. Physically, I was very strong and sound, but strength and fitness are only a couple of elements required to be a successful fighter. The importance of good technique in boxing is an extremely key element. With this, I did something I highly do not recommend doing. I compared myself to others. I felt that, in this case, it made sense. Although I can only be as good as I can be, I would be competing with another person, so why not compare myself to others? We need a means to measure where we are on our journey. Setting some timely milestones with quantifiable measurements is critical to identifying if we need to alter our course or focus in another area. As timely as it was, our coach, began having us spar one-on-one with the coaches inside the ring. These sparring exercises lasted for three full rounds, three minutes each round. Punch count and technique were monitored and measured where possible. After three rounds, we would hold reviews and discussions about how we were doing. In my case, I

learned my technique was coming along well, my fitness level was good, but my punch count needed to come up. I was around 120 punches per round in sparring and coach wanted it around 180! He said it wouldn't be that high in the actual fight, but for training purposes, he wanted it up there. So, a large percentage of my focus shifted to address this potential barrier to me competing at my highest capability.

Exercise: Checking In

Let's chose some check-in dates and place them in our calendar. Time intervals should be based on your action plan, however a minimum of once a month is preferable.

Check-In Dates

	Check-In Date	Status: On Track, Behind, Barriers)	Actions
	(end of month one)	*Running into lack of support*	*Have discussions with key people in my circle*
1			
2			
3			
4			

Stickiness – Staying Power

One of the most difficult things we encounter when reinventing ourselves and experiencing change, is making it stick. Studies show it takes 21 days to make a new habit stick. During this time, the luster and shine of what you began, will wear off, but you need to keep going. It's like a new

exercise program. You're enthusiastic at first, but then that enthusiasm and other barriers come into play. These need to be overcome. You'll have to find ways to keep things interesting, exciting, and engaging for yourself. A variety of whatever you are doing, is a good way to keep everything fresh. Don't get caught doing the same activities, especially if they are not giving you the results you need. Seek out different ways to accomplish your goals along the way.

> *"Consistency of effort over the long run is everything. Many of us, it seems, quit what we start far too early and far too often. Even more than the effort a gritty person puts in on a single day, what matters is that they wake up the next day, and the next, ready to get on that treadmill and keep going."*
>
> Angela Duckworth

When in your life have you needed to have *grit*? It may very well be the most important supporting factor as you endure the challenges presented. Be sure to gain strength from these past times and realize success will be yours! When reinventing ourselves, we need to have this *grit* quality. Relive a story, a time in your life, when you exhibited some form of *grit*. This will help strengthen you in difficult times. It is a reminder that you do, indeed, have what it takes to be successful!

> *"Enthusiasm is common. Endurance is rare."*

Exercise: Previous Positive Experience

Write about a time when you exhibited *grit*. Include as many details as you remember, including the strong physical and mental aspects you displayed. How did you show passion and persistence? Write so you remember your *grit* and transfer this positivity to your current situation.

The time I showed GRIT, passion and persistence, was when I ……

"Everything in life has a price, which probably separates winners from losers in business, sports, and life itself. If you're not prepared to pay the price, you can't expect to succeed."

Robert Herjavec

Rules – Breaking the Rules

"You can play within the rules, or you can play with the rules. Those that understand the rules can benefit from them."

I have always been one to push boundaries. To challenge the status quo. To bend and play with rules. After all, they're just guidelines, right? As a driven personality, I have always sought out ways to gain an advantage in most situations. Being in sales, for a large period of my career, and now coaching and mentoring in this field, learning the rules so you can manipulate them in your favour was essential to success. Now, you may be thinking, what are the rules when looking to reinvent oneself? In our case, for this journey, rules are actually self-imposed guidelines to assist in your success.

Related Story – Rules of the Ring

One Saturday morning, during our fighter training at the gym, our coach began sharing with us some of the rules of fighting. You may think there

aren't any rules in fighting, but there are. Many. She shared with us that rules are in place in boxing as they are in anything. They are there to ensure combatants and competitors, compete on a level playing field. She also explained that knowing the rules and point scoring system will allow us to create a fight plan to help us win our fight. It was only by knowing the rules could you utilize them in your favour. We all learned the *do nots* first. No punching to the back of the head, no head butting (Thank goodness I did not sign up for MMA fighting!), no low blows, no punches after the bell, etc. More importantly, we were taught how the point system worked during a fight. There would be several judges who would be scoring the fight, round by round. At the end of each fight, they would add their scores up to determine the winner.

Yes, one could win by having the referee count out their opponent—this was called a technical knockout. But a technical knockout was not the goal. The goal was to accumulate more points than your opponent. A punch landing past a fighter's guard, and landing anywhere above the waistline, was granted one point. A blocked punch received no points. It was important to know that the location or power of your punch did not matter. Even tapping your opponent would be granted one point.

Knowing the rules of engagement and how we will measure success is a crucial determining factor in how we play the game, or flourish on the journey. Ensure you understand the rules and how you will use them to assist you along your path to your goal. In my case, I learned that the speed of my jab allowed me to land often on my opponents. Landing it high and low, because of the reach of my God-given, knuckle-dragger arms, as my kids often referred to them, the points piled up. This technique reduced the risk of my opponent landing punches on me, because I remained too far for him to reach me. So, while I kept a safe distance, I landed jab after jab—high jabs, low jabs, double jabs—all while racking up point after point. Occasionally, my opponent would land or come close to landing one, but I knew I was winning with the rough estimated count in my head. I was making use of my strengths defined in my own fight SWOT.

Exercise: Setting Your Own Rules

For me during my fight, I set the following rules for myself:

1. Stay within my game plan, do not deviate, do not allow my opponent to take me off or change my game

2. Use my strengths, minimize weaknesses and threats

3. Control my ego

What are some rules you plan to stick with during your journey?

1. _____

2. _____

3. _____

Chapter Nine

REFLECTION - USING THE PAST PRODUCTIVELY

*"Those who fail to learn from history are
doomed to repeat it."*

Sir Winston Churchill

Reflection is an important step in any process. Reflection allows us to revisit the events of the recent past and learn from them. We can repeat what went well and give thought to how to handle the ones that didn't go well, so these have better outcomes the next time. We must always look forward, but we have to understand our history in order to not repeat the mistakes of the past. I have seen too many instances where people continue to pursue wrong courses of action because they do not take the time to think critically about what has happened in the past.

Allow those around you to support you, encourage you, and keep you accountable to meet your goals. Be prepared for the upcoming CRAP and barriers and meet them head-on as needed. If some of these change your timing or path slightly, go with it, but do not change your goals. Continue to work your plan. How you measure your success and achievement is up to you. Make these measurable, so you can concretely know whether something worked or not. And be sure to celebrate small wins along the way! After all, apart from reaching the end goal, this is a journey with many victories to be celebrated.

Chapter Ten

CALL TO ACTION!

"There is no passion to be found playing small - in settling for a life that is less than the one you are capable of living."

Nelson Mandela

Regardless of whether your reinvention comes from choice or a necessity, keep these things in mind on your journey of change. Even when we know changing is for our own good, it's easy to resist it, and to prefer our comfortable old habits. Take time to identify your W.I.I.F.M.s or What's In It For Me? This is your motivator and will keep you going through discomfort. If you can't identify a positive benefit, ask what loss or negative outcome you are trying to avoid.

Surround yourself with positive people who keep your energy levels high, and do not let negative people impose their stresses and difficulties upon you. These people are full of drama and stress and should be avoided. They are toxic and will make change extremely difficult. Identify the people in your life who drain your energy and distance yourself from them. Conversely, identify those who make you feel supported, and bring you an abundance of energy. Spend more time with these people.

When we are approaching a change, it can seem daunting. When we've made it through to the other side, it's easy to look back with perspective and call it growth. Keep this in mind as you encounter adversity, challenges, and barriers. So far, you've navigated every change thrown your way. That's a pretty good track record.

"To get something you never had, you have to do something you never did."

Remember, if you want to behave differently, you have to think differently. We can retrain our brains and form new habits. It just takes courage and the willingness to step outside our comfort zones. Change can be scary, but by taking some time to proactively manage and strategize your plan, you can set yourself up for success in reaching your reinvention goals. I would wish you luck, but you don't need it. Luck is when preparedness and opportunity meet. You are now very prepared. And your opportunity lies within your reinvention. Embrace your journey. You've got this!

"There is something you must always remember. You are braver than you believe, stronger than you seem, and smarter than you think."

Winnie the Pooh